INNER DIMENSIONS

THE RADIOGRAPHIC WORLD *of* WILLIAM CONKLIN

WRS
PUBLISHING

A Division of WRS Group, Inc.
Waco, Texas

Dedication

To my own shell collectors:
My wife, Bette,
my daughters, Patti and Liz,
and my son, Chip,
for their contributions, patience, and
understanding of my shell world.

First published in the United States of America in 1995
by WRS Publishing, A Division of WRS Group, Inc.,
701 N. New Road, Waco, Texas 76710
Book design by Kenneth Turbeville
Jacket design by Joe James

Printed in Hong Kong

10 9 8 7 6 5 4 3 2 1

Library of Congress Cataloging-in-Publication Data

Conklin, William A.
 Inner dimensions : the radiographic world of William Conklin.
 p. cm.
 ISBN 1-56796-063-4 : $29.95
 1. Shells--Radiography. 2. Shells--Pictorial works. 3. Shells-
-Poetry. I. Title.
 QL404.C65 1995
 594'.0471'0222--dc20 94-22181
 CIP

Acknowledgments

The author is indebted to many who have aided directly or indirectly in the publication of this book.

Alan Shoemaker, zoologist, Riverbanks Zoological Park, Columbia, South Carolina, my friend and consultant, whose advice was invaluable in compiling this publication.

Christine Boldt, librarian and author, whose compilation of poetry has added a beautiful timeless and ageless quality to the shell art.

Dr. Clyde F. E. Roper, curator, Department of Invertebrate Zoology, National Museum of Natural History, Smithsonian Institution, Washington, D.C., who was instrumental in having my first one-man photographic exhibition at the National Museum of Natural History in 1978.

My appreciation goes to the Association of Science Technology Centers, Washington, D.C., the South Carolina State Museum, and the directors and curators of the following museums, hospitals and colleges who had four- to twelve-week exhibitions of work from the Inner Dimension Collection: Museum of Virginia, Richmond; Delaware Museum of Natural History, Greenville; Dallas Health and Science Museum; Museum of Texas Tech University, Lubbock; Museum of Natural Science, Louisville; Bell Museum of Natural History, Minneapolis; Springfield Science Museum, Springfield, Massachusetts; Museum of Science & Space Transit Planetarium, Miami; Buffalo Museum of Science; Reading Public Museum and Art Center, Reading, Pennsylvania; Cincinnati Museum of Natural History; Museum of Science, Boston; The Exploratorium Palace of Arts & Science, San Francisco; The Charleston Museum, Charleston, South Carolina; Maryland Science Center, Baltimore; Nature Science Center, Winston-Salem; Cumberland Museum, Nashville; Center of Science and Industry, Columbus, Ohio; Morningside Nature Center, Gainesville, Florida; Robert Vines Environmental Science Center, Houston; Insights-El Paso Science Center, El Paso; Omniplex, Oklahoma City; Suffolk County Community College, Riverhead, New York; The Conservancy Nature Center, Naples, Florida; Chicago Academy of Sciences; Riverbanks Zoological Park, Columbia, South Carolina; Richland Memorial Hospital, Columbia, South Carolina; Museum of York County, Rock Hill, South Carolina; I.P. Stanback Museum & Planetarium, South Carolina State College, Orangeburg; and McKissick Museums, University of South Carolina, Columbia.

A special thank-you to the writers and newspaper editors throughout the country and to the editors of *Southern Living; Sandlapper Magazine; Radiologic Technology; DuPont Magazine; Shellfish Digest; South Carolina Wildlife; International Wildlife; Living in South Carolina; Caminos del Aire; Scienza & Vita; Ford Times; Science Digest; The New Book of Knowledge Annual; Popular Photography;* and *Dynamic Years* for publishing articles on my art.

A thank-you also to my friend and freelance writer Ann Blask of Orchard Park, New York. Many of her articles on my shell art were published in the magazines listed above.

To shell collectors Hildur Wallsten, Shrewsbury, Massachusetts; Ann Joffe, Sanibel Island, Florida; Kay Casparis, Cape Coral, Florida; Dolores Stilljes, Sullivan's Island, South Carolina; Maggie Yergin, Mount Pleasant, South Carolina; Richard Sweeney and Gunta Avens, Albany, New York; and Joanne Ellison, Omaha, Nebraska. I thank you for giving or lending me shells from your personal collection for use in this book.

Sincere appreciation goes to H. Filmore Mabry, administrator, Orangeburg Regional Hospital, for the use of X-ray equipment; to radiologists J. Harvey Atwill, Jr., Dallas Lovelace, and Jim Edinger for their encouragement and constructive advice; and to radiologic technologists Jackie Kelly, Ernie Phillips, Ben Moore, Yancy Wells, and Terry Campbell for their assistance in so many ways.

I also wish to thank the technical representatives of Eastman Kodak Company, Fuji, Agfa-Gevaert, and DuPont for their donations of color slide films and/or X-ray films that were used to make many of the color and black-and-white photographs in this book.

Table of Contents

Acknowledgments .. iii

Foreword ... vii

Introduction ... viii

Preface ... xi

Angel Wings ... 2

Fluted Clam .. 4

Giant Atlantic Cockle ... 6

Heart Cockle ... 8

Lion's Paw Scallop .. 10

Ox Heart Clam .. 12

Wedding Cake Venus .. 14

Arthritic Spider Conch ... 16

White Buccinum ... 18

Burnett's Murex .. 20

Channeled Whelk .. 22

Neapolitan Triton .. 24

Graceful Fig .. 26

Grinning Tun .. 28

Ventral Harp ... 30

Hebrew Volute .. 32

Horse Conch ... 34

Juno's Volute .. 36

Knobbed Whelk .. 38

Common Spider Conch ... 40

Lettered Olive ... 42

Melon Shell ... 44

Black-Spined Murex .. 46

Woodcock Murex .. 48

Pearl Trochus .. 50

Pink-Mouthed Murex ... 52

Precious Wentletrap .. 54

Papery Rapa .. 56

Scotch Bonnet ... 58

Spindle Tibia ... 60

Lister's Conch ... 62

Sundial .. 64

Ten-Ridged Whelk .. 66

Giant Tun .. 68

Pacific Triton .. 70

Venus Comb Murex .. 72

Worm Shell ... 74

Common Paper Nautilus 76

Chambered Nautilus ... 78

Chambered Nautilus ... 80

Spirula .. 82

Emperor's Slit Shell .. 84

Glory-of-the-Sea ... 86

Golden Cowry ... 88

Maple Leaf Shell ... 90

Martin's Tibia ... 92

Alabaster Murex .. 94

Keyhole Sand Dollar ... 96

Japanese Carrier Shell ... 98

Achatina Pantherina ... 100

Foreword

Inner Dimensions is a remarkable collection of wonderful "inside views" of both the world of shells and the human mind. Poetry is in many ways the breath of the soul, and when combined with the raw beauty of nature, it becomes a compellingly positive force. This rare collection of X-rays and classical poetry features in one volume an artistic view from modern society as well as the timelessness of the written word.

Following the discovery of the X-ray by Wilhelm Conrad Roentgen in 1895, there came a flood of predictions regarding this imaging method, including the ability to photograph the human soul. We are, of course, no closer to this lofty goal today, in spite of advances like the computerized axial tomography (CAT) scan and magnetic resonance imaging (MRI) scan, than we were over a century ago when this marvelous medical imaging tool was first discovered. Contained within the energy spectrum of the X-ray is the power to view the very core of each of us and that of our natural surroundings. Aiding immediately in the diagnosis and treatment of medical disorders, the discovery of the X-ray will forever serve as a marker of the beginnings of modern medicine. Advances in the medical uses of the X-ray were remarkably swift, but no sooner had this new-found discovery been expounded as the end-all to medical woes than were its limitations and hazards realized. We found, as can be so clearly seen in the X-ray art of the shells presented here, that the intricacies of the muscle, tendon, organ, vessel, and nerve were to be seen only as vague gray shadows on the background of the skeleton beneath. Although a variety of methods of introducing substances visible by X-ray were devised, it was not until the applications of CAT scans and MRI scans in the 1970s and 1980s that visualization of the most delicate of human tissues by medical imaging became possible. However, less than a year after Roentgen's discovery of X-rays, the potential healing power of this "secret ray" was being utilized to treat cancer. Nearly simultaneous with this new-found use for the "Roentgen ray" were the first reports of possible harmful side effects of the X-ray, and ultimately the reality of "radiation"-induced disease. Later we were to again view the powerful potential of harmful radiation during the testing and use of atomic weapons. Perhaps this is yet another commentary on the relationship between the X-ray and the inner dimensions of mankind; which encompasses not only the ability to create, but also the capacity to destroy. As was true for Mrs. Roentgen, for many who first view their own skeleton on X-ray, there is a premonition of death.

Amazingly, each of us annually receives enough "X-rays" from simply living on our planet that, if collected in a single dose each year, would prove sufficient to supply the needed strength to generate several of the pictures displayed in this volume. In a lifetime we will each receive enough "natural" X-rays to produce the X-ray images in this book! Imagine what form of energy is used and required to actually fuel the creativity of the poets featured here. Although we can measure the energy of a single cell and can calculate the calories that would need to be consumed over some finite period of time for the brain's basic metabolic requirements, we are nary a hair's breadth closer than a century ago to understanding the true nature of the creative mind. It is, by far, the most powerful force known to mankind, and one which can dominate even the strongest forces unleashable on earth. The human mind is but an amorphous glob of gelatinous tissue, weighing generally less than a pound, but capable of feats no less than a symphony.

Through the marvels of X-ray technology, we have enabled our society to view the true physical nature of the inner appearance of the human body, and through work such as that presented here, the marvels of the inner dimensions of nature. The inner alcoves of the emotional heart, mind, and soul, nonetheless, remain hidden from view. It is only through the frosty mirror of writings such as those we find in this book that women and men are able to fleetingly glimpse from whence they derive their own real Inner Dimensions.

William W. Orrison, Jr., M.D.
Professor of Radiology
University of New Mexico School of Medicine

Introduction

By Alan H. Shoemaker, Zoologist
Riverbanks Zoological Park, Columbia, S.C.

It is often said that shell collecting is as old as civilization itself. For early and more recent peoples, shells served as money in China from 2000–600 B.C., in Sudan and Uganda through the end of the late nineteenth century, and in North America by both Indians and colonists until 1800; as ornaments and jewelry in ancient Egypt and Greece, Mayan Central America, and the Pacific Northwest; and in the case of large tritons, as heralds of ceremony in Minoan and Neolithic civilizations of the Mediterranean, in funeral services on Tonga, and for leading soldiers into battle in the Society Islands. And from diverse beginnings like these, shell collecting as we know it evolved.

Shell collecting can be documented historically because of the fascination it held for royalty and persons of high position. The collections of the Roman consuls Laelius and Scipio of the second century B.C. are lost in time, but those of more recent rulers have become the nuclei of many national scientific collections. Among notable collectors, Louis XIII of France, Peter the Great and Catherine II of Russia, and Maria Theresa of Austria were famous in their pursuits; and Emperor Hirohito of Japan continues in their royal footsteps.

The seriousness of collectors was established in expansionist-minded Europe during the eighteenth century when flag-raising expeditions ventured far afield in search of gold, spices, medicines, and influence. A fringe benefit to science were the massive shell collections that were returned. Voyages of Capt. James Cook, for instance, resulted in significant natural collections of shells and other wildlife and are credited as the primary reason other nations organized naturalist expeditions for the good of science.

We tend to think of shells, and particularly the larger or more colorful species, as being typical of the tropics. This is often translated to mean that they are the most valuable shells, and in this vein, early expeditions of the nineteenth century were often directed toward those regions. This theme is perfectly understandable since biological principles that govern the distribution and physical appearance of all animals regulate mollusks just as they do fish, birds, or insects.

Animals of all kinds, both vertebrates and invertebrates, are paler in color and less ornate when living near the poles, and darker and more structurally intricate toward the equator. "Darker" means not only a deepening of color, but also a tendency toward brighter colors and more intricate patterns. Small wonder, then, that the finely detailed patterns of cones, cowries, and volutes are limited to the more tropical species.

Another trend that enhances the tropics in the mind of many collectors concerns speciation. In any group within the plant or animal kingdom, there exist far fewer species near the poles than near the equator. These habitats, or "niches," are broader and more general near the poles; and species, few though they are, compensate for this situation by producing greater numbers of individuals. Near the tropics there are many more niches, but because of their abundance they are narrower in scope and definition. This explains why there are so many species, one per niche, in the tropics; but owing to the small niche size, there are correspondingly fewer individual specimens per species. The highly restrictive nature of some tropical niches accounts for some species' extreme rarity: the depth, island habitat, food source, or some other factor may become so specialized that few specimens ever exist.

Within the large worldwide group of soft-bodied animals scientists call mollusks, some classes are better known than others. Without a doubt gastropods and bivalves, the one- and two-shelled members of this phylum, are the best-known and sought-after group for collectors. Cephalopods (the squids, octopuses, and nautiluses) are also famous but more often in a culinary context. Most have no external skeleton, a factor which eliminates their collectibility for the average person, and only the Chambered nautilus and kin enjoy much popularity among conchologists.

The tooth shell or scaphopod possesses a tubular shell with an opening at each end. Its resemblance to an elephant's tusk is uncanny, but the small size and drab coloration renders it of little interest to most shell collectors. Another minor group, dubbed Gastroverms, are known only from extreme depths and are found primarily in museum collections. Aside from their inaccessible habitat, the gastroverm's small size and drab coloration would probably evoke little interest in most collectors.

The remaining group of collectible shells, albeit a distant third, are the chitons. Also called Coat-of-mail shells, these marine "armadillos" are constructed of eight overlapping plates that are embedded in a muscular girdle. The plates protect the animals from the elements and their enemies, and permit them to graze on rocks exposed to heavy seas. Although not as sought after as bivalves and gastropods, chitons do have their aficionados, and some shell dealers regularly include them in their offerings.

Traditionally shell collections have evolved around marine species, with gastropods and bivalves occupying 99 percent of most collectors' attention. And regardless of whether the collector beachcombs along nearby shores, buys specimens from mail order suppliers, or enjoys the luxury of travel to faraway places, the broad range of habitats and forms ensures that there will be something for everyone.

The seas and coastal areas in all parts of the world have unique properties

and dependent animal life. Different areas of the world are described on the basis of the predominant country or physical factor and are called faunal provinces. Some countries have representatives from only one faunal province; other areas have species typical of several. The molluscan assemblage in the Southeast includes a number of species found only from North Carolina to Florida, Texas, and the Caribbean, and this zone is called the Carolina Province. Other species are found all along the East Coast from northern Florida to New England. Many of the exotic species in this book are typical of the Indo-Pacific, Japonic, or Panamic (West) provinces.

Most mollusks are adapted to specific habitats and occupy a certain niche within the marine community. Important factors that control diversity include salinity, substrate type, tidal depth, and food requirements, with minute variations in any one factor capable of causing a change in the niche's occupant. In some instances, a single species of animal can be the primary nucleus of an entire habitat, with all other organisms dependent on its survival. The oyster bed of the East Coast of the United States is such a situation, and counterparts may be found throughout the world. More diverse niches controlled by several physical factors include such places as intertidal estuarine mudflats, subtidal marine grass beds, and offshore coral reefs. In keeping with the trend of increased speciation toward equatorial regions, such changes have greater effect in the tropics.

In the formative years of conchology—the science of shell collecting—most people were limited to local species unless a friend was involved in distant travel or exploration. This is one of the principal reasons why eighteenth century shell collecting was primarily a hobby of the rich and famous. Today things are vastly different. Not only is travel available on a scale commensurate with the pocketbook, but armchair collecting through mail order sources also increases the scope of one's collection. Physical demands are no longer a major hurdle, and only the availability of rare species remains a major obstacle for the serious conchologist.

In the early days of exploration, shells arrived from the far reaches of the world with little precise information on their origin. For over a hundred years the St. Thomas Cone was known only from a half-dozen specimens, and its exact habitat remained a mystery. The first specimen introduced to science was thought to have originated in the Indian Ocean, a sweeping statement to say the least. Only in the last decade have scientists found living specimens in the central Moluccas of Indonesia, and then only near a single island.

Some species were common in collections of the nineteenth century because refueling stations for ships were needed in out-of-the-way places. Shells endemic to these islands vanished from trade once air travel eliminated the need to visit these bastions of conchology, and some species became rare and remain so to this very day.

Similarly, species from distant places that were known from only a small number of specimens may now be relatively common. Lister's Conch commanded prices exceeding $1,000 when it first became available to collectors in 1970. Fifteen years later one can be had for as little as $10—all because their precise habitat was located during the process of expanded exploration for fisheries.

Are there more species out there waiting to be named? One has only to scan dealers' 1985 price lists offering shells from Australia and Honduras to realize that exploration is continuing. The major difference is that today's captains aren't searching for gold and spices, but new and richer fishing grounds. In the process, new volutes and slit shells, to name just a few, continue to appear from depths previously thought to be too deep or barren to bother with. Most new species are coming from greater depths, but science also helps us understand specimens already in hand. Some species we thought were merely variable in form are now known to be distinct species, this time distinguished on the basis of their tooth structure, which is visible only through the aid of the electron microscope.

Today, shell enthusiasts have a new avenue of appreciation—radiology. Although this science of X-ray technology has been around for many years, its application has been restricted to medical and scientific uses. The artist and conchologist have not had the opportunity to peer inside this wonder structure we call the shell and see how these creatures cloak themselves in calcium. Now, with Bill Conklin's expertise, good fortune, and ingenuity, a new "inner dimension" for the shell collector unfolds. Within this volume, a better understanding of the evolving shell becomes available and provides us with a greater appreciation of one of nature's marvels.

Preface

Probably when man found the first seashell washed ashore on a lonely beach or observed his first seagull dropping an oyster or clam on a rocky shore to break it open and devour its contents, he developed a never-ending association with seashells and the mollusks within the shell. Whether it be common oysters, scallops, clams, mussels, or whelks, early man relied on mollusks as a constant source of food, easily obtainable and rich in protein. The shells, too, proved to be indispensable and were valued for their beauty, size, shape, and configuration. Over thousands of years shells have been used as currency, musical instruments, adornment, vessels, tools, weapons, and as medicine for treating a variety of ailments. And, the shell was thought to be magical, mystical, and steeped with religious connotations. Today, the shell still has an influence on society and is coveted for its beauty and the nutritional value of its creator. It is also used as a design for logos, jewelry, stamps, calendars, greeting cards, and other products; it has inspired poets, artists, writers, mathematicians, architects, and photographers.

When it seems that all that can be done with shells has been done, the author, by use of radiography and photography, presents a new and different form of art—the inner dimensions of seashells. There are about 80,000 known species of marine, freshwater, and land shells which are divided into six basic classifications: gastropods, bivalves, cephalopods, tusk shells, chitons, and monoplacophora. The shells chosen for this book are limited to gastropods, bivalves, and cephalopods, and have been selected for their beauty, their external and internal design, and their unusual shape and configuration.

From Sea Voices

I love the very sea-song in the shell
 Which holds a strange sweet music for the ear;
Deep in its chambers ocean murmurs dwell,
 And chimes of surging waters, faint but clear.

by Charles Dent Bell (1818–1898)

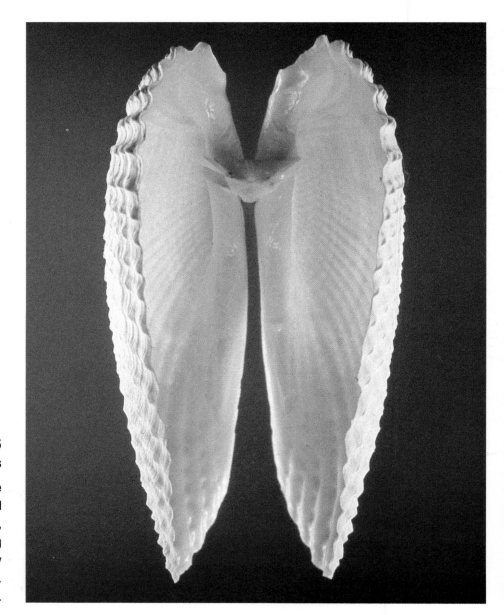

A n g e l W i n g s
Crytopleura costata Linnaeus

Angel Wings are the largest of the boring clams and, despite
their fragile appearance, are able to bore to a meter or more in mud
and hard clay. By closing and opening their adductor muscles,
the shell rocks back and forth using its anterior edge as a cutting
edge. Angel Wings live intertidally or in shallow water, but easily
accessible beds are becoming scarce because of overcollecting.
10–12 cm. New Jersey to Brazil. Common.

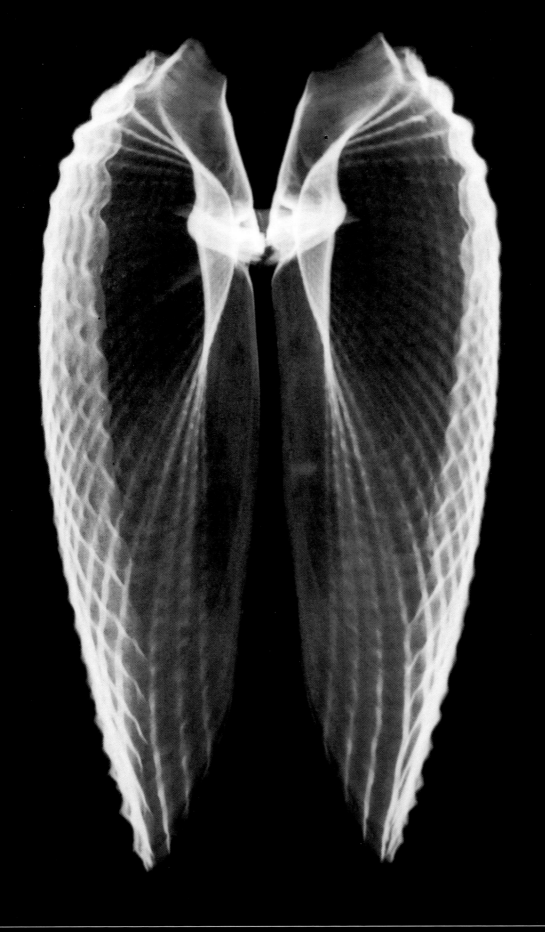

Angel Wings

Sea Shell

Sea Shell, Sea Shell,
 Sing me a song, O please!
A song of ships, and sailormen,
 And parrots, and tropical trees,

Of islands lost in the Spanish Main
Which no man ever may find again,
Of fishes and corals under the waves,
And sea horses stabled in great green caves.

Sea Shell, Sea Shell,
 Sing of the things you know so well.

by Amy Lowell (1874–1925)

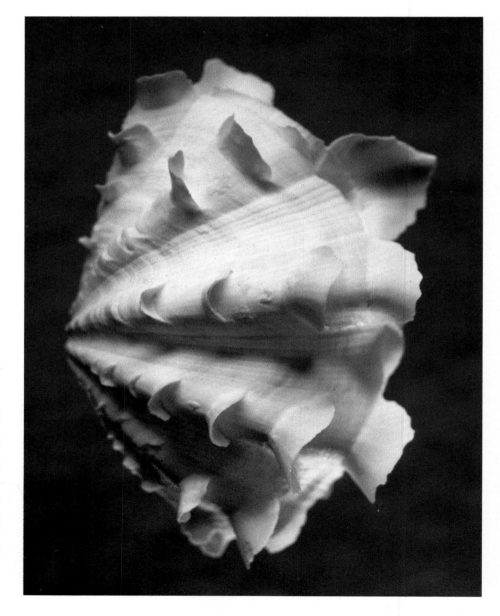

Fluted Clam
Tridacna squamosa Lamarck

Related to the erroneously infamous Giant Clam, the small Fluted Clam varies widely in color from shades of off-white to bright oranges and yellows. The long scales that sometime extend beyond the shell's edge are characteristic of the species. At the point of the valve's union, a large opening permits the bysis, a solidified mass of threads, to extend from the shell's interior and anchor it to the bottom. Fluted Clams possess colonies of algae within their tissue in a relationship where both plant and animal receive food or shelter.

8–40 cm. Japan to South Africa. Common.

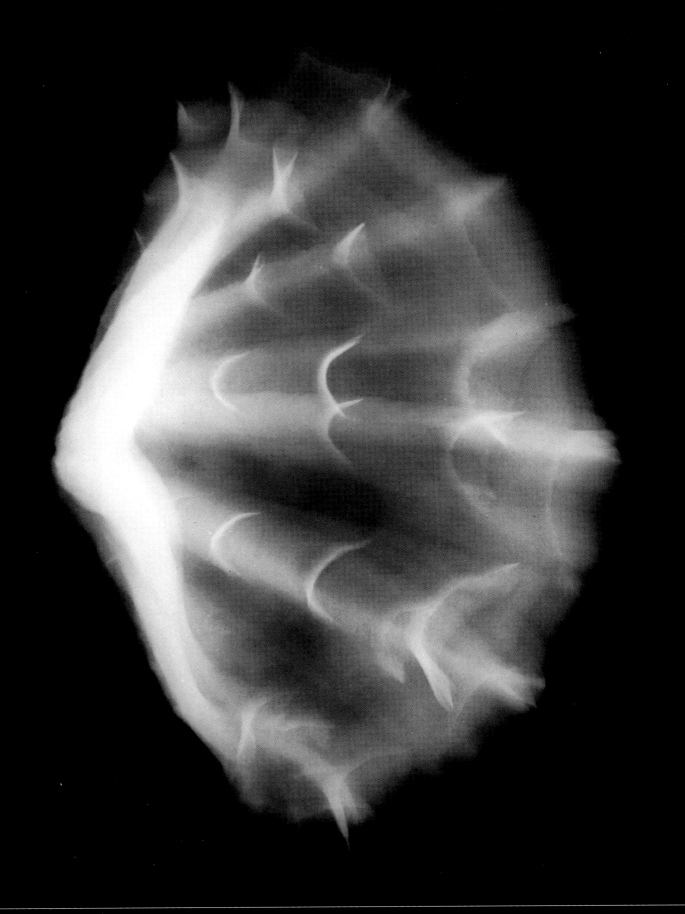

Fluted Clam

From A Sea Shell

Oh, when I read the mystic shell,
That makes a music in my blood
Of every ancient shore and flood
And wakens dreams I cannot tell,
Within its storied bosom curl'd;
I bathe within the founts that flow
From the dim lands of Long-ago,
And water all the living world.

by Frederick William Orde Ward (1843–1922)

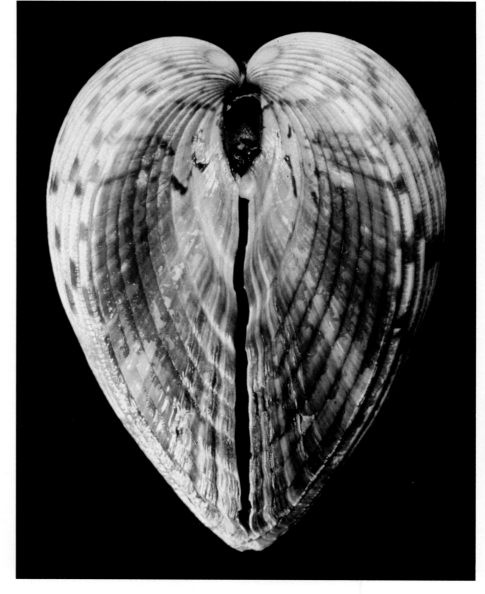

Giant Atlantic Cockle
Dinocardium robustum Lightfoot

A large bivalve, the Giant Atlantic Cockle is very often found on
South Atlantic and Caribbean beaches. The animal, itself, is dark reddish
in color, much like the shell, and is widely used in chowder.
2–10 cm. Common.

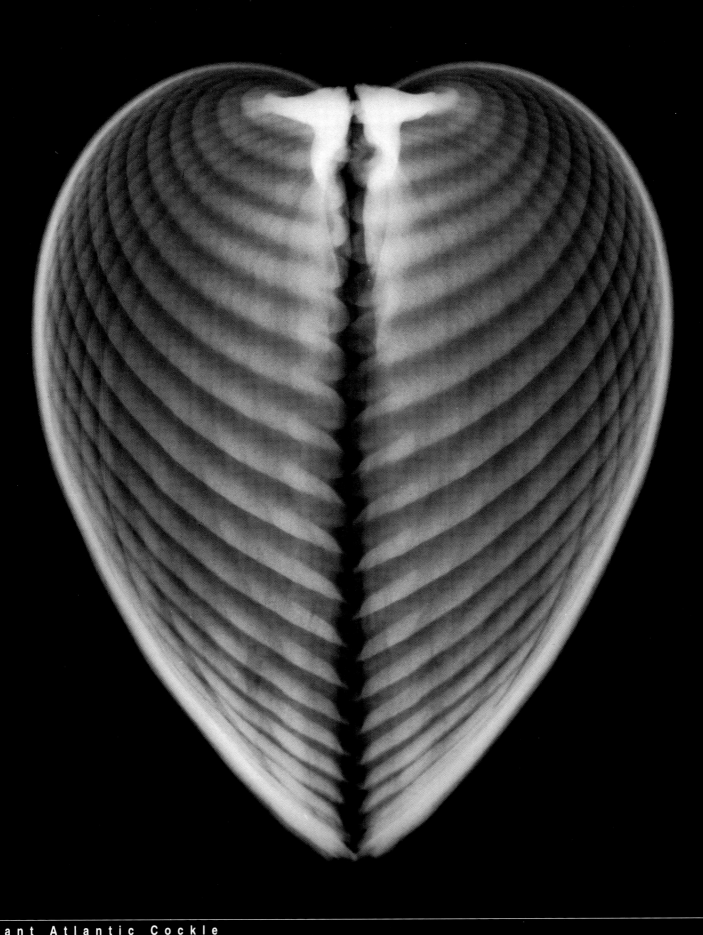

Giant Atlantic Cockle

From A Thing of Beauty

A thing of beauty is a joy for ever:
Its loveliness increases; it will never
Pass into nothingness; but still will keep
A bower quiet for us, and a sleep
Full of sweet dreams, and health, and quiet breathing.
Therefore, on every morrow, are we wreathing
A flowery band to bind us to the earth,
Spite of despondence, of the inhuman dearth
Of noble natures, of the gloomy days,
Of all the unhealthy and o'er-darkened ways
Made for our searching: yes, in spite of all,
Some shape of beauty moves away the pall
From our dark spirits.

by John Keats (1795–1821)

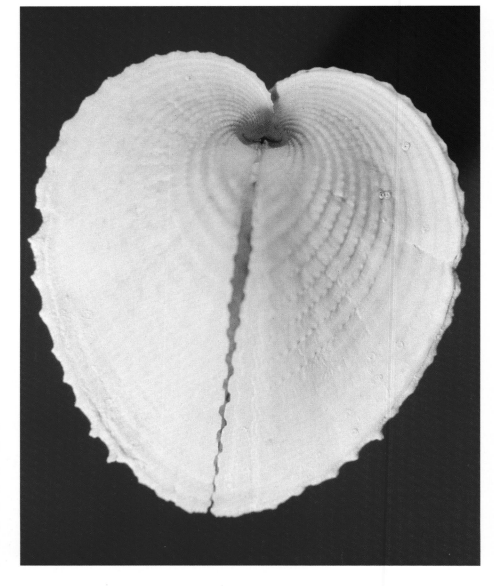

Heart Cockle
Corculum cardissa Linnaeus

A unique member of the well-known cockle family found in virtually all parts of the world, Heart Cockles are distinctly heart-shaped, with one side of the shell being more convex than the other. A strong keel edges the shell, ornamented by numerous fine-pointed projections. Heart Cockles come in a wide range of delicate colors which span from white to pink to yellow.
5–8 cm. Indo-Pacific. Common.

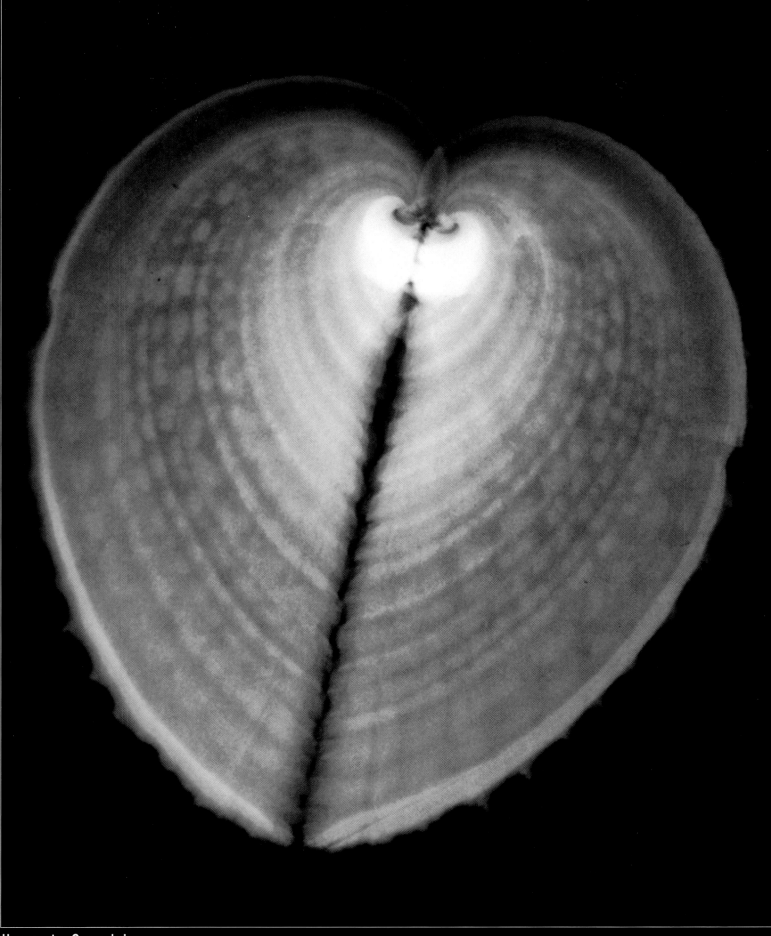

Heart Cockle

The Passionate Man's Pilgrimage

From

Give me my scallop shell of quiet,
My staff of faith to walk upon,
My scrip of joy, immortal diet,
My bottle of salvation,
My gown of glory, hope's true gage
And thus I'll take my pilgrimage.

by Sir Walter Raleigh (1552–1618)

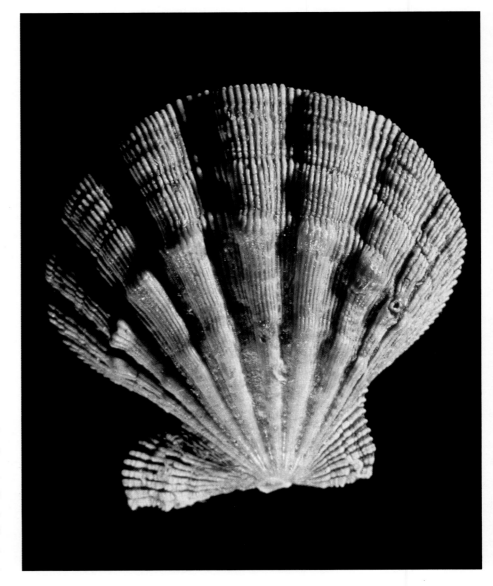

Lion's Paw Scallop

Lyropecten nodosus Linne

A favorite of collectors is the brightly colored Lion's Paw Scallop.
The ribs have enlarged nodules that resemble a lion's knuckles and the
shells may come in many colors of red, orange, brown, or yellow.
When threatened by danger, they snap their valve shut and, with
water jettisoned from their shell, zigzag for short distances.
8–12 cm. Florida-West Indies. Common.

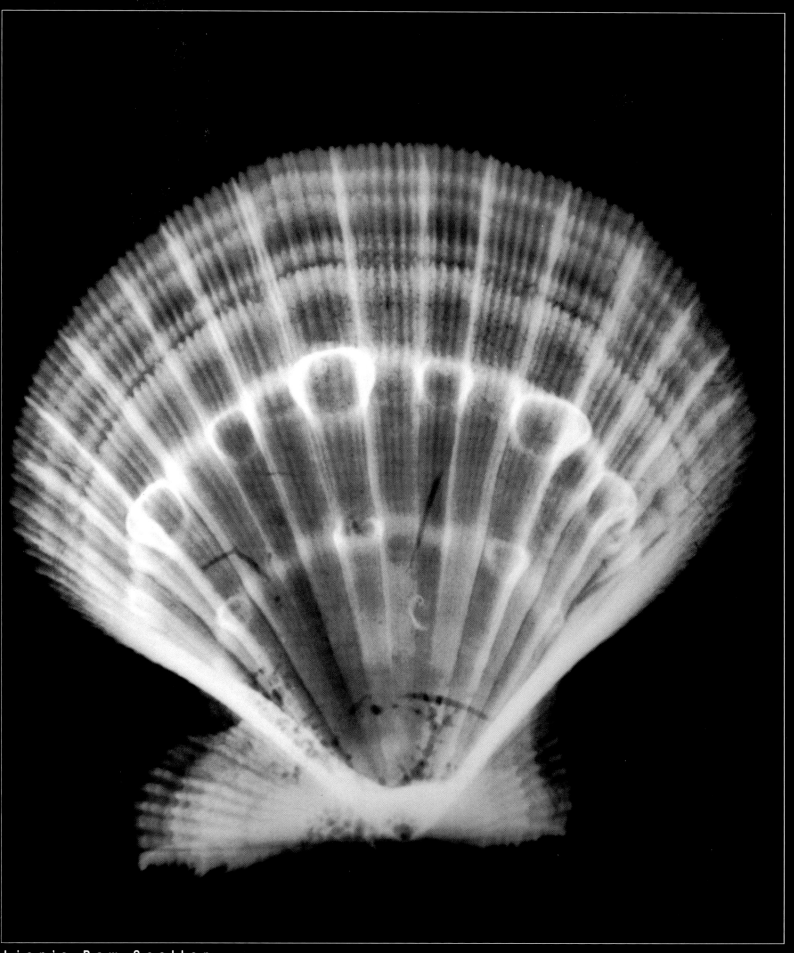

Lion's Paw Scallop

From Maud

See what a lovely shell,
Small and pure as a pearl,
Lying close to my foot,
Frail, but a work divine,
Made so fairily well
With delicate spire and whorl,
How exquisitely minute,
A miracle of design!

What is it? a learned man
Could give it a clumsy name.
Let him name it who can,
The beauty would be the same.

The tiny cell is forlorn,
Void of the little living will
That made it stir on the shore.
Did he stand at the diamond door
Of his house in a rainbow frill?
Did he push, when he was uncurl'd,
A golden foot or a fairy horn
Thro' his dim water-world?

Slight, to be crush'd with a tap
Of my fingernail on the sand,
Small, but a work divine,
Frail, but of force to withstand,
Year upon year, the shock
Of cataract seas that snap
The three decker's oaken spine
Athwart the ledges of rock,
Here on the Breton strand!

by Alfred, Lord Tennyson (1809–1892)

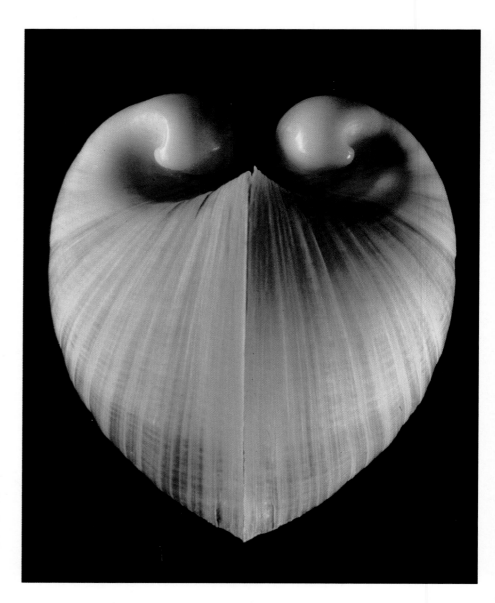

Ox Heart Clam
Glossus humanus Linnaeus

The Ox Heart Clam is found offshore in relatively deep water and
is prized as much for its nutritional value as the beauty of the shell.
3–6 cm. Western Europe; Mediterranean. Common.

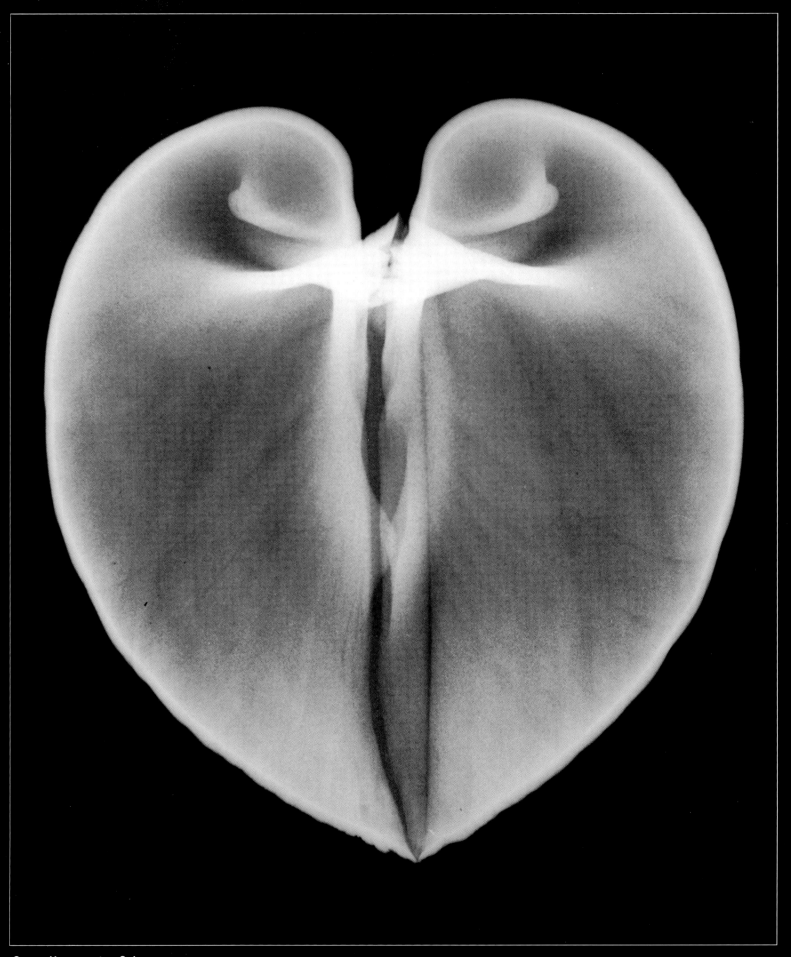

Ox Heart Clam

From Auguries of Innocence

To see a World in a grain of sand,
And a Heaven in a wild flower,
Hold Infinity in the palm of your hand,
And Eternity in an hour.

by William Blake (1757–1827)

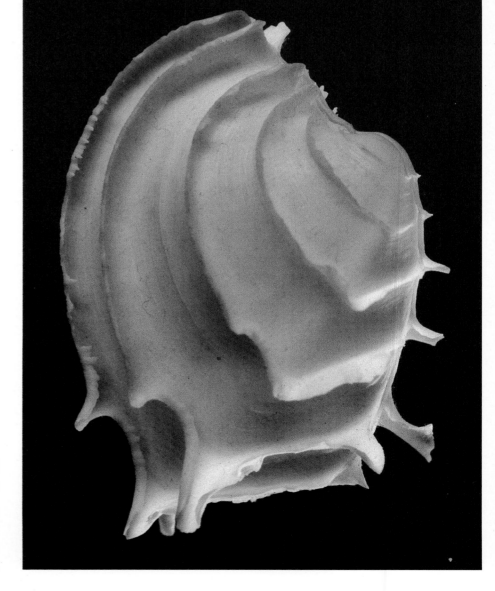

W e d d i n g C a k e V e n u s
Bassina disjecta Perry

The heavily ribbed Wedding Cake Venus of South Australia and Tasmania
is an uncommon member of the widely ranging Venus clams. Many similar,
but less strongly structured species, are found in the West Atlantic.
6–7 cm. Uncommon.

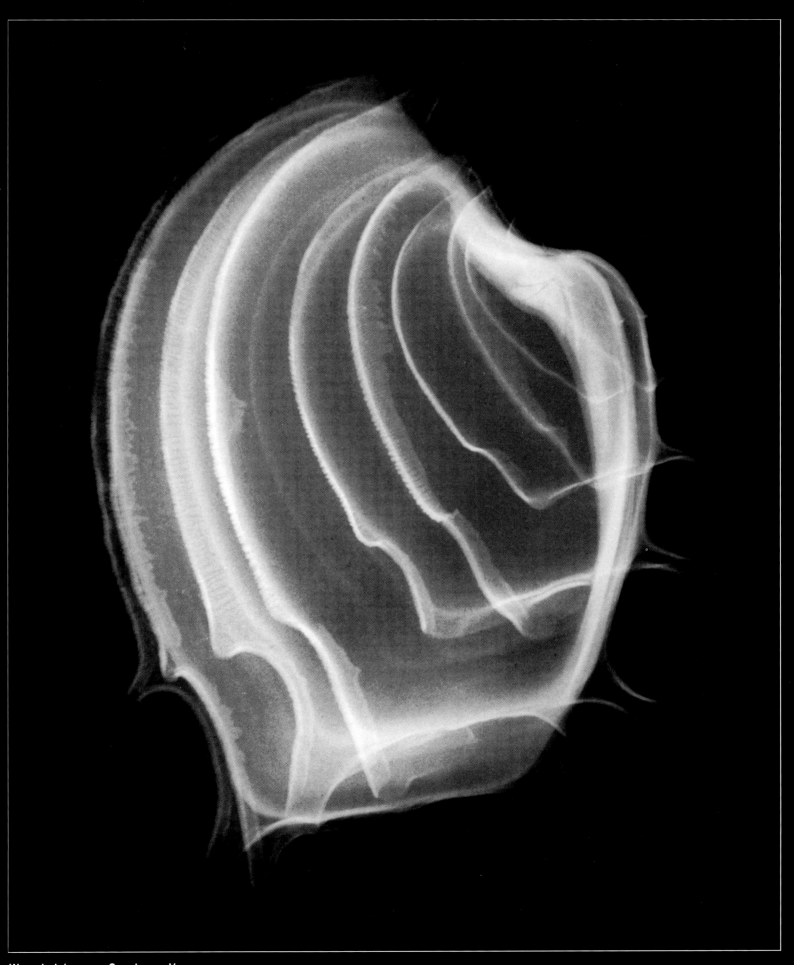

Wedding Cake Venus

A Quatrain

Hark at the lips of this pink whorl of
 shell
And you shall hear the ocean's surge and
 roar:
So in the quatrain's measure, written
 well,
A thousand lines shall all be sung in four!

by Frank Dempster Sherman (1860–1916)

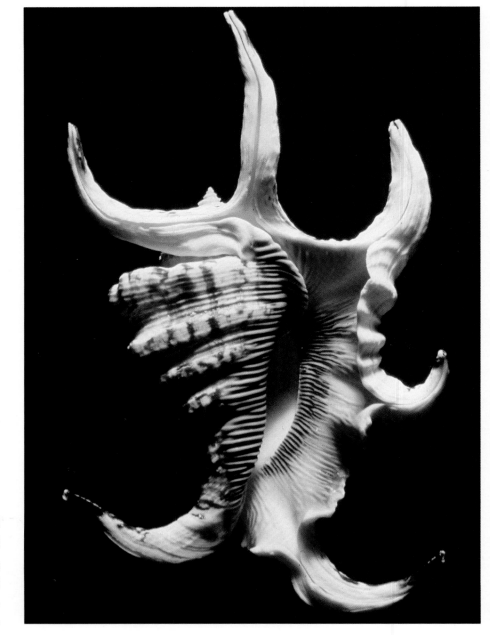

Arthritic Spider Conch
Lambis arthritica Roding

The Arthritic Spider Conch does not develop its long spines
until fully mature. While still a juvenile, spiders resemble the unspined
conchs and cones. Vegetarians, they lay spaghetti-like egg masses.
15 cm. Indian Ocean. Uncommon.

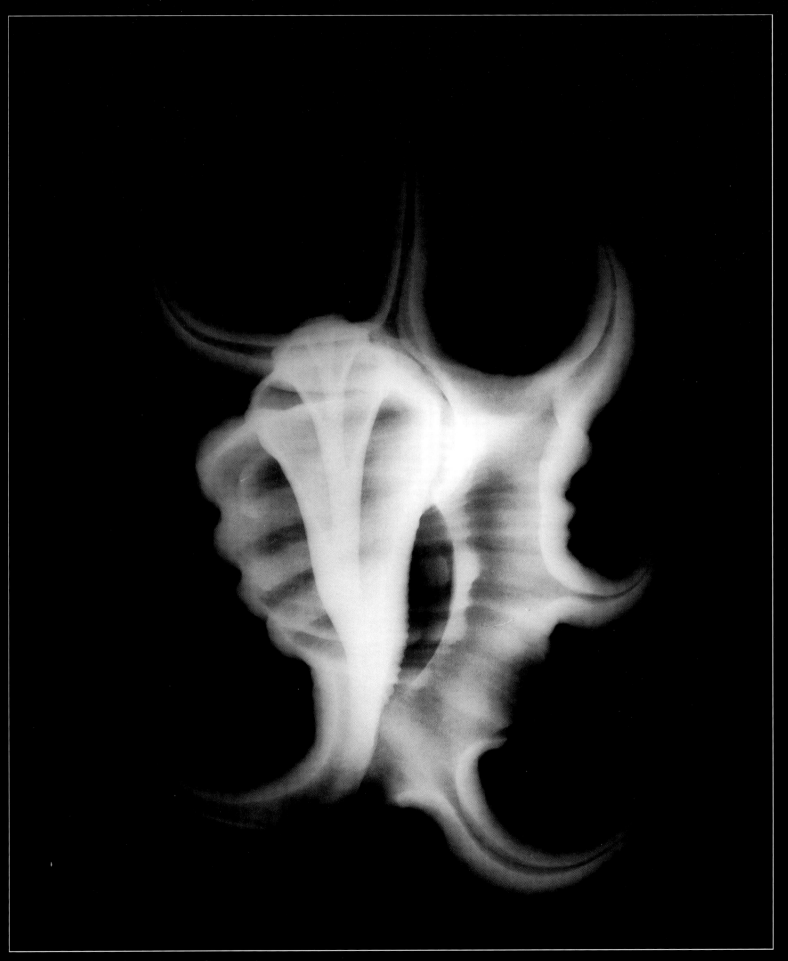

Arthritic Spider Conch

From Implicit Faith

In Sound's unmeasured empire thus
 The heights, the depths alike we miss:
Ah, but in measured sound to us
 A compensating spell there is!
In holy music's golden speech
 Remotest notes to notes respond:
Each octave is a world; yet each
 Vibrates to worlds its own beyond.
Our narrow pale the vast resumes;
 Our sea-shell whispers of the sea:
Echoes are ours of angel plumes
 That winnow far infinity.

by Aubrey Thomas De Vere (1814–1902)

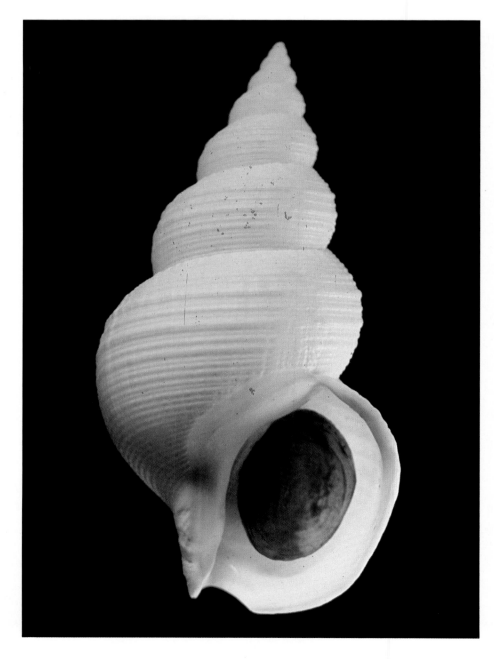

White Buccinum
Buccinum leucostum Lischke

This Buccinum, a deep water species obtained by offshore trawling
operations, is seldom seen alive. While this species is glossy and finely
sculptured, most of its relatives are rather drab, thick, unimpressive shells.
Buccinums of all species are found in colder water near the poles or at
great depths where they feed on a wide variety of invertebrates.

8 cm. Japonic. Common.

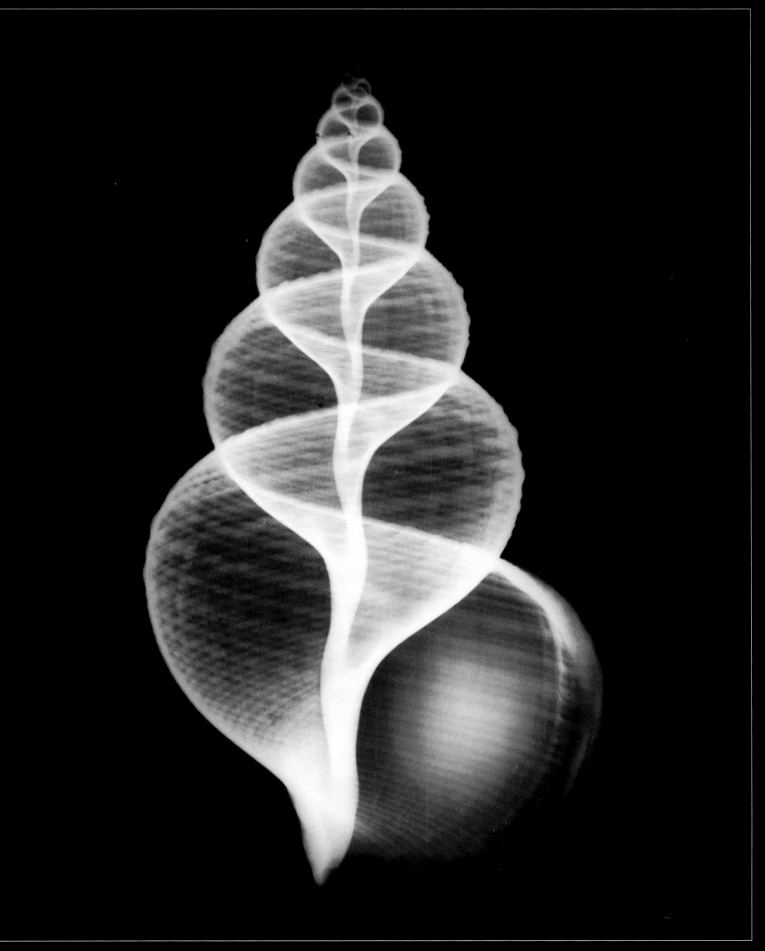

White Buccinum

From The Secret of the Sea

…**W**ill it ne'er be spoken? O vast encircling Sea!
Thine is the voice eternal of the life that is dumb in me:
I hear in thy surging thunder the sound of my soul's unrest;
And thy fathomless depths of silence are the dream-deep
 life of my breast.
Murmur, O Sea, thy message; speak to me, deep to deep:
We are swept by the same fierce passions; we sleep the same
 moonlit sleep:
For I think that thy restless waters through the gulfs of my life
 have rolled;
And I think that my heart has suffered whatever thy waves
 have told.
Speak to me, spirit to spirit, thou art more than symbol or sign;
For thine are the very pulses of the life that is lost in mine…

by Edmond Gore Alexander Holmes (1850–1936)

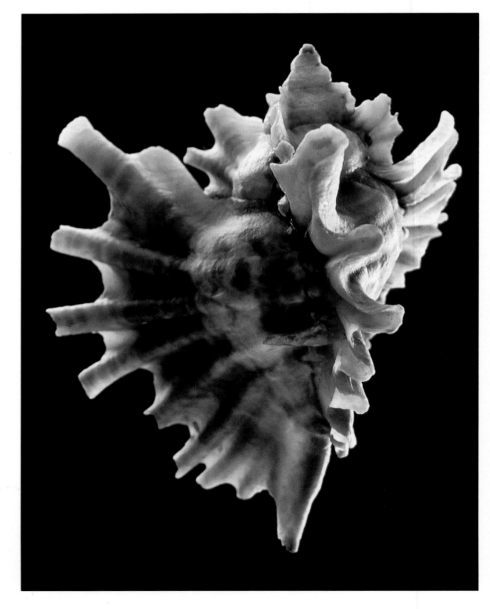

B u r n e t t ' s M u r e x
Ceratostoma burnetti Reeve

An unusually large, thick member of the Murex family,
Burnett's Murex, with its brown to gold coloring and frilly
spines, is a worthy addition to any shell collection.
10 cm. Japonic. Uncommon.

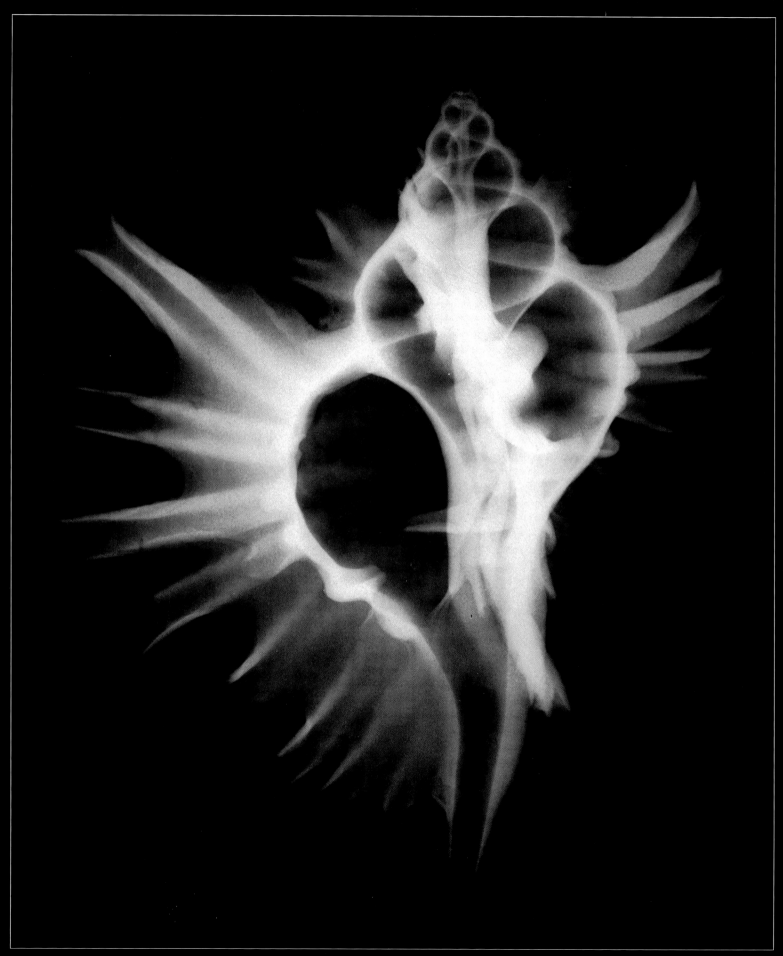

Burnett's Murex

From

The Excursion

I have seen
A curious child, who dwelt upon a tract
Of inland ground, applying to his ear
The convolutions of a smooth-lipped shell,
To which, in silence hushed, his very soul
Listened intensely; and his countenance soon
Brightened with joy, for from within were heard
Murmurings, whereby the monitor expressed
Mysterious union with its native sea.
Even such a shell the universe itself
Is to the ear of Faith; and there are times,
I doubt not, when to you it doth impart
Authentic tidings of invisible things;
Of ebb and flow, and ever-during power;
And central peace, subsisting at the heart
Of endless agitation.

by William Wordsworth (1770–1850)

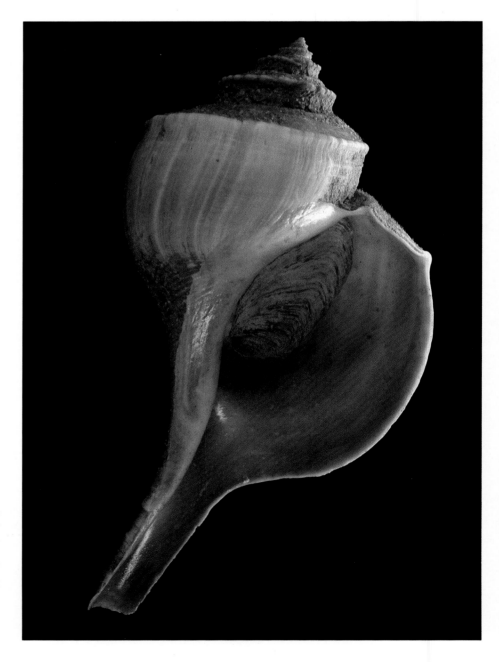

Channeled Whelk
Busycon canaliculatum Linne

A large, carnivorous gastropod, Channeled Whelks are
common predators of bivalves. Clams are opened by inserting
the snout, then chipping the prey's shell apart with its own lip.
Their exterior is covered by a thick, fuzzy covering, or periostracum.
2–20 cm. Massachusetts to Florida. Common.

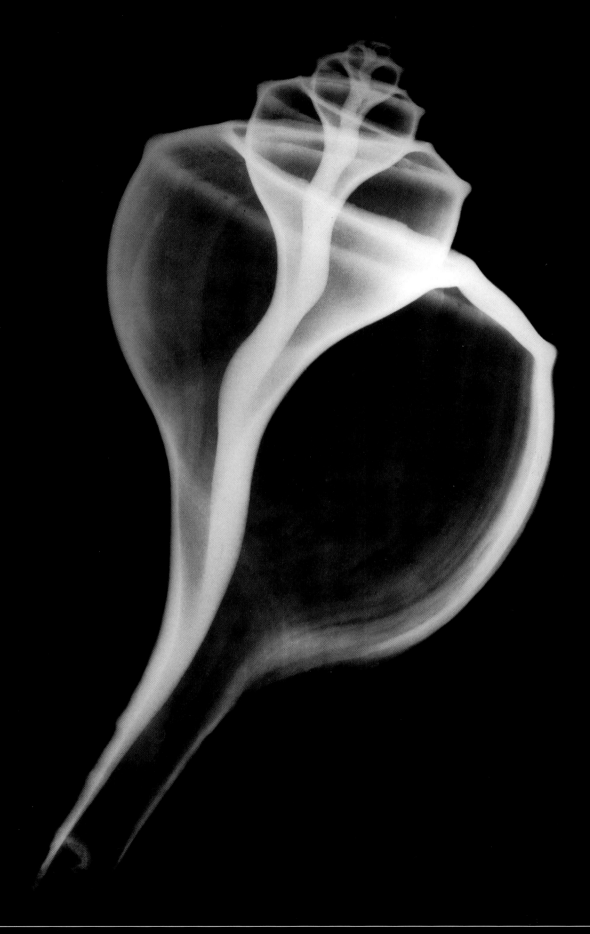

Channeled Whelk

Ebb and Flow

I WALKED beside the evening sea,
And dreamed a dream that could not be;
The waves that plunged along the shore
Said only—"Dreamer, dream no more!"

But still the legions charged the beach;
Loud rang their battle-cry, like speech;
But changed was the imperial strain:
It murmured—"Dreamer, dream again!"

I homeward turned from out the gloom,—
That sound I heard not in my room;
But suddenly a sound, that stirred
Within my very breast, I heard.

It was my heart, that like a sea
Within my breast beat ceaselessly:
But like the waves along the shore,
It said—"Dream on!" and "Dream no
 more!"

by George William Curtis (1824–1892)

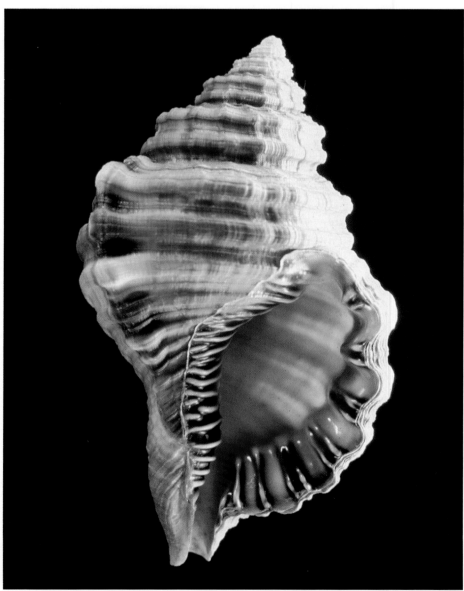

Neapolitan Triton
Cymatium parthenopeum Von Salis

This is a solid, thick shell, beautifully sculptured.
The thick outer lip has several pairs of teeth.
10–14 cm. South Florida, West Indies, Bermuda. Common.

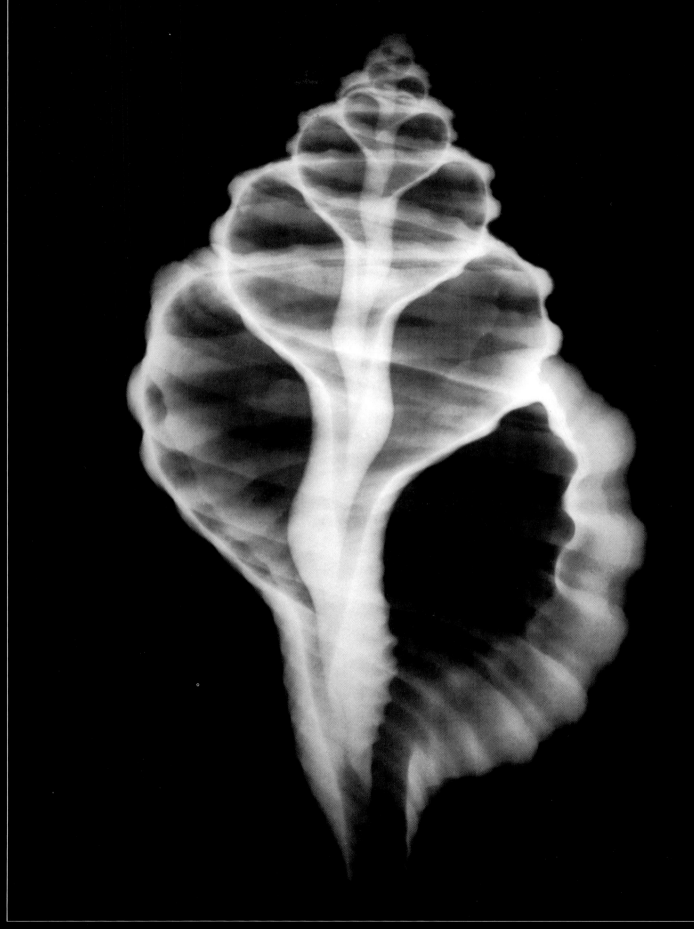

Neapolitan Triton

Sea-Shell Murmurs

The hollow sea-shell which for years hath stood
 On dusty shelves, when held against the ear
 Proclaims its stormy parent; and we hear
The faint far murmur of the breaking flood.

We hear the sea. The sea? It is the blood
 In our own veins, impetuous and near,
 And pulses keeping pace with hope and fear
And with our feelings' every shifting mood.

Lo, in my heart I hear, as in a shell,
 The murmur of a world beyond the grave,
Distinct, distinct, though faint and far it be.

Thou fool; this echo is a cheat as well,—
 The hum of earthly instincts; and we crave
A world unreal as the shell-heard sea.

by Eugene Jacob Lee-Hamilton (1845–1907)

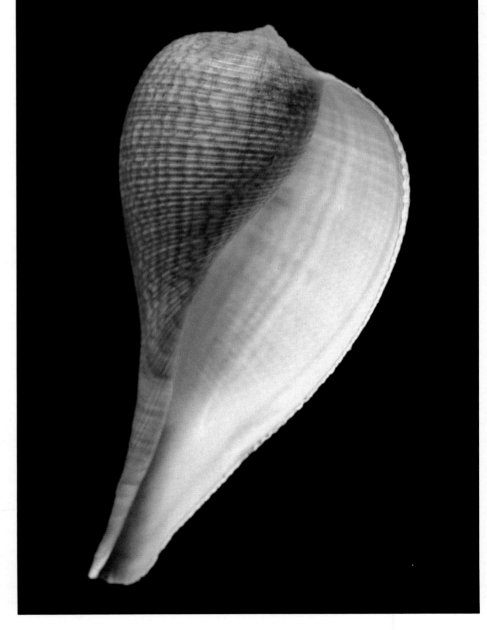

Graceful Fig
Ficus gracilis Sowerby

The Graceful Figs possess remarkably thin, lightweight shells
seemingly too fragile to survive the effects of wave action and currents.
Actually, their lightweight shells cope quite well under adverse conditions,
the large bodied animal enveloping the shell to protect it from abrasion.
Graceful Figs, like those in other seas, live on shallow sand bottoms where
they search for sea urchins and starfish, their main prey. Most of the
fifteen species are natives of the Pacific and similar in appearance.
10–15 cm. China Sea. Frequent.

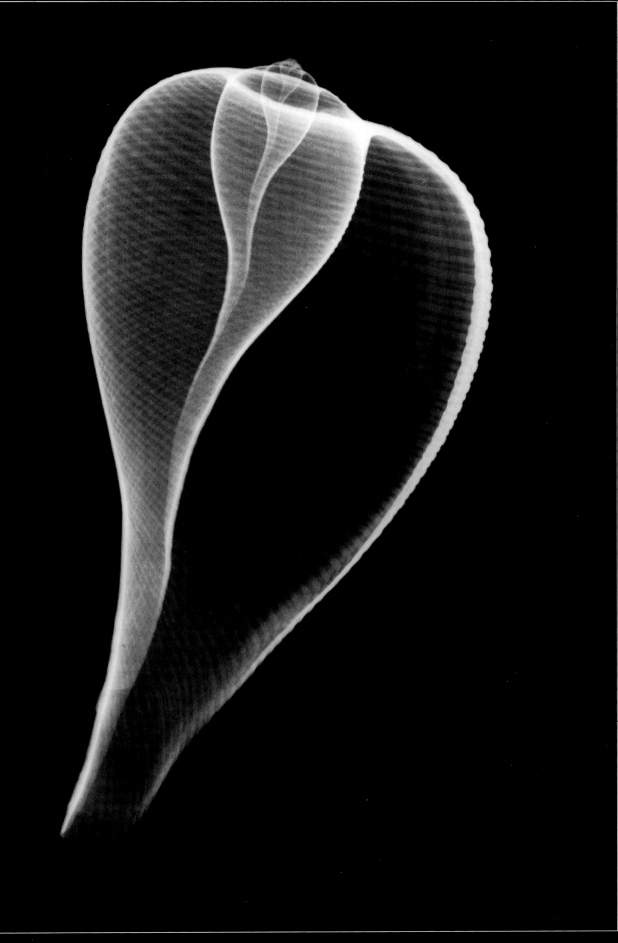

Graceful Fig

Sea-way

The tide slips up the silver sand,
 Dark night and rosy day;
It brings sea-treasures to the land,
 Then bears them all away.
On mighty shores from east to west
It wails, and gropes, and cannot rest.

O Tide, that still doth ebb and flow
 Through night to golden day:—
Wit, learning, beauty, come and go,
 Thou giv'st—thou tak'st away.
But some time, on some gracious shore,
Thou shalt lie still and ebb no more.

by Ellen Mackay Hutchinson Cortissoz (d. 1933)

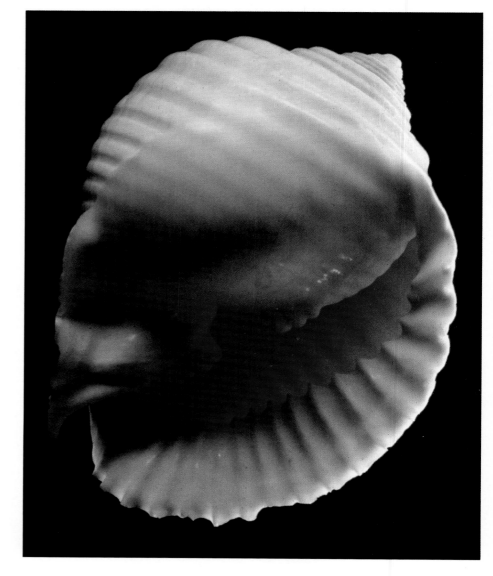

G r i n n i n g T u n
Malea ringens Swainson

The Panamic Province, extending from West Mexico to Peru,
hosts a number of unique species isolated from the rest of the world.
One of these, the Grinning Tun, has several demonstrative "teeth" and the
ever present "notch" that separates it from other members of its family.
12–17 cm. Panamic. Common.

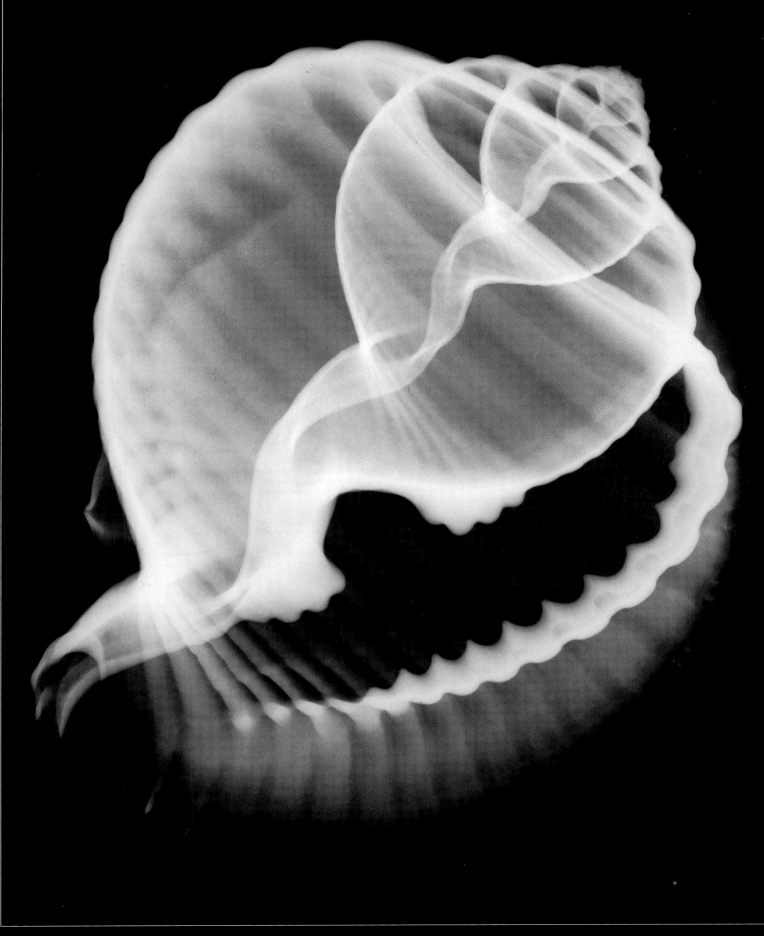

Grinning Tun

The Sea Shell on the Desert

Mournful murmurer, whence thy music,
　　Singing chimes of distant seas?
Constant harper, bard in exile,
　　Come, translate thy rhapsodies.

"Mid the waters green I listed,
　　Billows sing and oceans roar,
And the flowing in the deepness,
　　And the thunder on the shore.

"For in far back generations
　　Here the tides majestic ran:
Time's remorseless transmutations
　　Dried them to a burning span.

"And those boundless waters spurned me
　　With their strong tempestuous hand;
Great, and huge, and wild, they cast me
　　Into exile on the strand.

"But the sea that bore me perished,
　　With its million mighty waves;
Sleeps the music that it cherished
　　In their lone and arid graves.

"Mountains lofty shake their heather
　　Where the depths of water flowed,
And where coral paths were shining
　　Winds the dry and dusty road.

"Yet the memory of those oceans,
　　And the grandeur of their tone,
I, the bard, whom they rejected,
　　Cherish and record alone."

by Ernest Charles Jones (1819–1868)

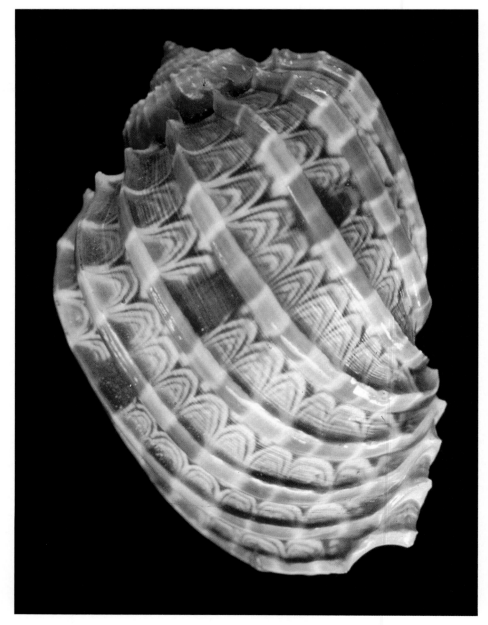

Ventral Harp
Harpa ventricosa Lamarck

Ventral Harps have bright color patterns and raised
axial ribs. They lack an operculum and are carnivorous.
6–9 cm. Indo-Pacific. Common.

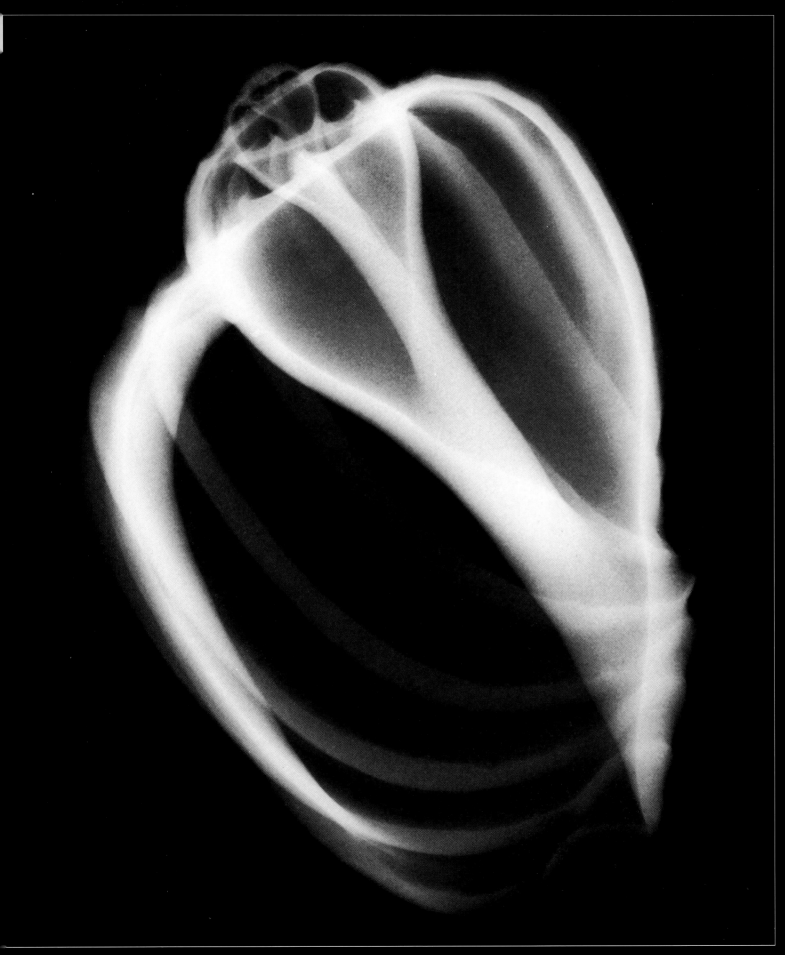

From

With Sa'di in the Garden

How opulent the unsullied marble spreads
With ornament, how decked with precious work
Of scroll and spray, volute and chasery,
And grave texts written clear in black and red
Inlaid upon the white…

———————— 〰 ————————

by Sir Edwin Arnold (1832–1904)

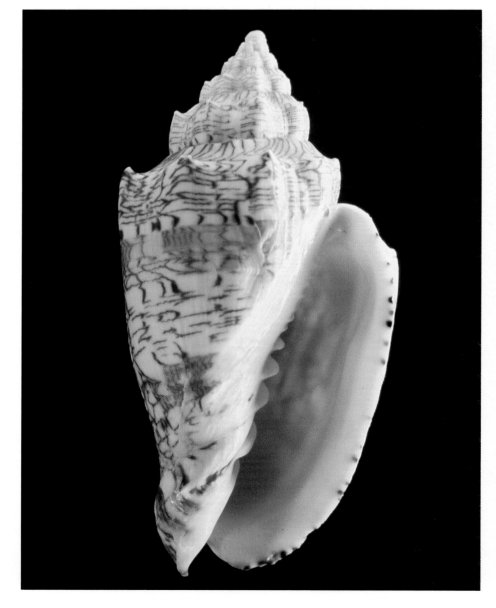

Hebrew Volute
Voluta ebrea Linnaeus

This is a beautifully sculptured, thick, massive shell
from the deep, warm water of tropical seas.
15 cm. Brazil. Uncommon.

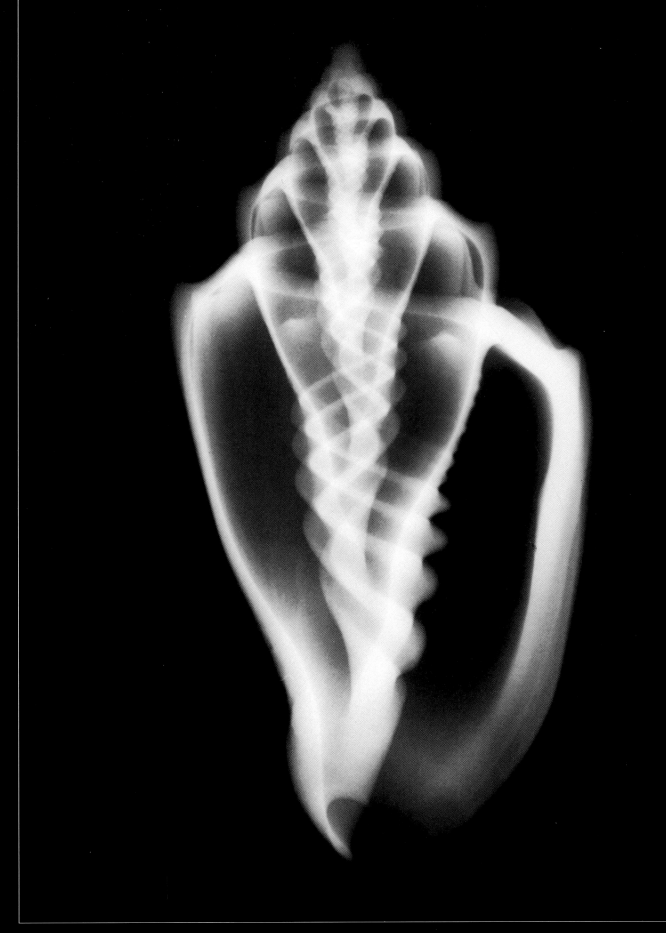

Hebrew Volute

From
Light Shining
Out of Darkness

God moves in a mysterious way,
His wonders to perform;
He plants his footsteps in the sea,
And rides upon the storm.

Deep in unfathomable mines
Of never failing skill,
He treasures up his bright designs,
And works his sovereign will.

by William Cowper (1731–1800)

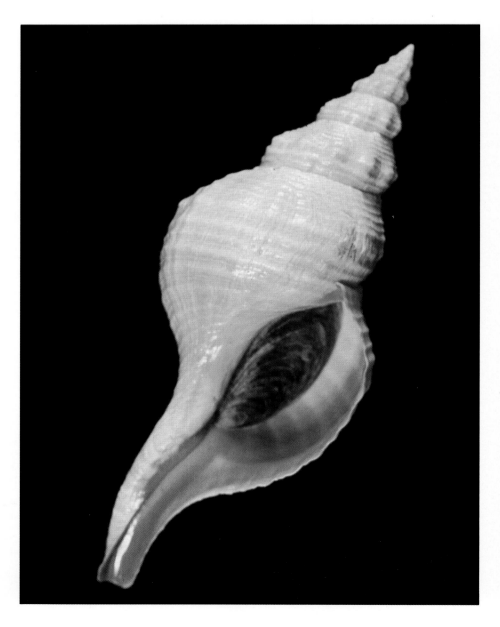

Horse Conch
Pleuroploca gigantea Kiener

The Horse Conch is the largest gastropod in the Western Atlantic. It lives in shallow waters and offshore grass beds. Specimens up to thirty inches in height have been reported, and it is thought that some adult species could live between twelve and fourteen years. It is edible but is said to have a peppery taste; it was called a "Pepper Conch" by early Florida settlers. The animal is a bright orange-red color. In keeping with its orange theme the Horse Conch was named the official Florida state shell in 1969, joining other "orange" symbols of the State of Florida. Governor Claude Kirk signed the legislative declaration into law using a ceremonial orange pen with orange ink.
40–60 cm. The shell ranges from North Carolina to Florida and the Yucatan. Common.

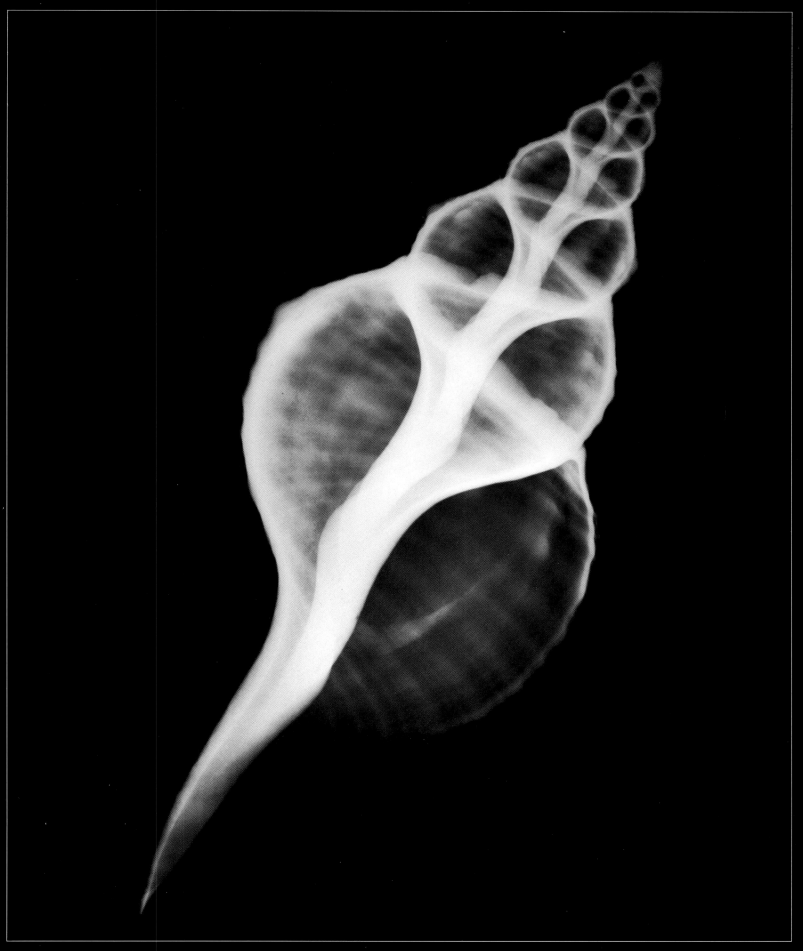

Horse Conch

Pied Beauty

Glory be to God for dappled things—
 For skies of couple-colour as a brinded cow;
 For rose-moles all in stipple upon trout that swim;
Fresh-firecoal chestnut-falls; finches' wings;
 Landscape plotted and pieced—fold, fallow, and plough;
 And áll trades, their gear and tackle and trim.

All things counter, original, spáre, strange;
 Whatever is fickle, frecklèd (who knows how?)
 With swíft, slów; sweet, sóur; adázzle, dím;
He fathers-forth whose beauty is pást change:
 Práise hím.

by Gerard Manley Hopkins (1844–1889)

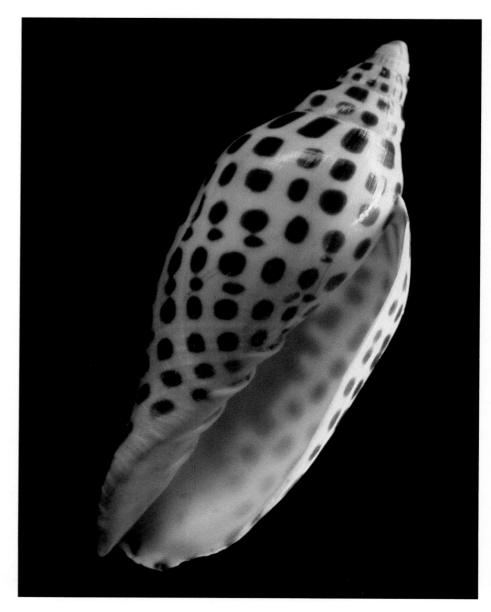

Juno's Volute
Scaphella junonia Lamarck

This colorful member of the Volute family has been highly prized by collectors since the Golden Age of shell collecting in the eighteenth century. It is now particularly prized by the shell collectors of Sanibel Island, Florida. Though specimens rarely come ashore from their deepwater homes except after severe storms, this is the single most sought after shell of the Florida beachcomber. Junonias live in association with reefs and sponge beds. *8–13 cm. Caribbean and Gulf of Mexico. Uncommon.*

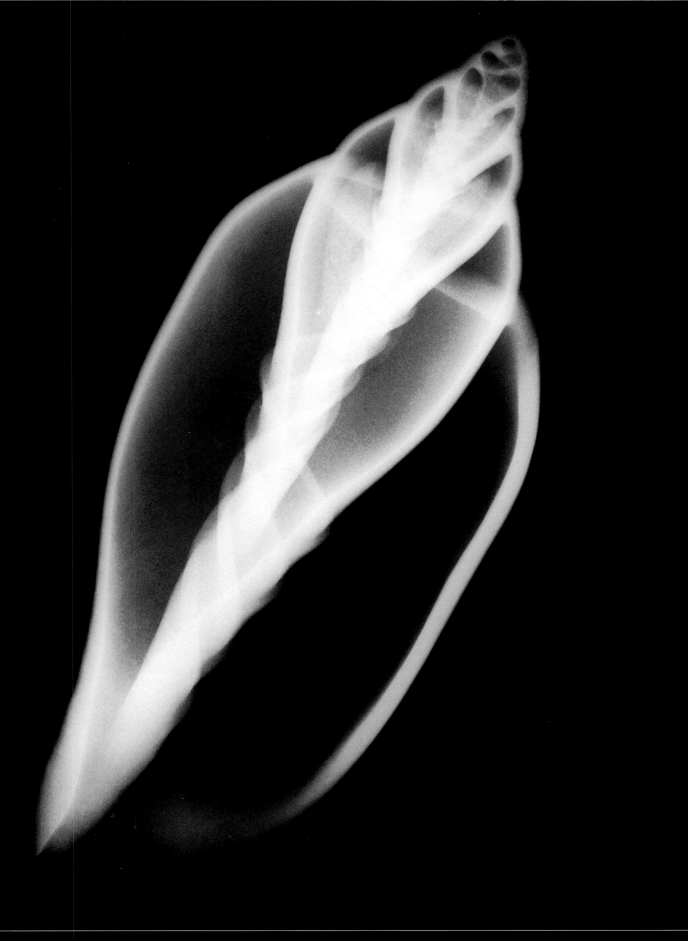

Juno's Volute

From Atlantis

While we are proud, as little children are,
To pick up some fair sea-shell, and then lay
Their ears to listen to its inner song
Oceanic, thunder of a sunken tide,
Glories that wail in far oblivion,
Faint sighs, yet breathing from the infinite,
That seem to say, 'We shall be heard again.'

by Frederick Tennyson (1807–1898)

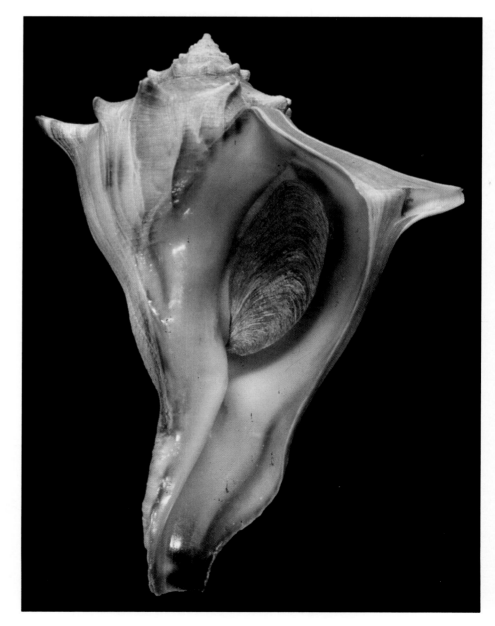

Knobbed Whelk
Busycon carica Gmelin

To vacationers of eastern North America, the Knobbed Whelk typified the "seashell." Whelks of this clan, called Fulgur whelks, developed sixty million years ago and are unique to the Western Atlantic. Knobbed Whelks feed on clams by pulling the valves apart with their muscular foot and wedging the tip of their own shell between the gaping valves. With the clam barred from closing, the whelk can then feed upon the hapless bivalve at its leisure.
14–20 cm. Cape Cod to North Florida. Common.

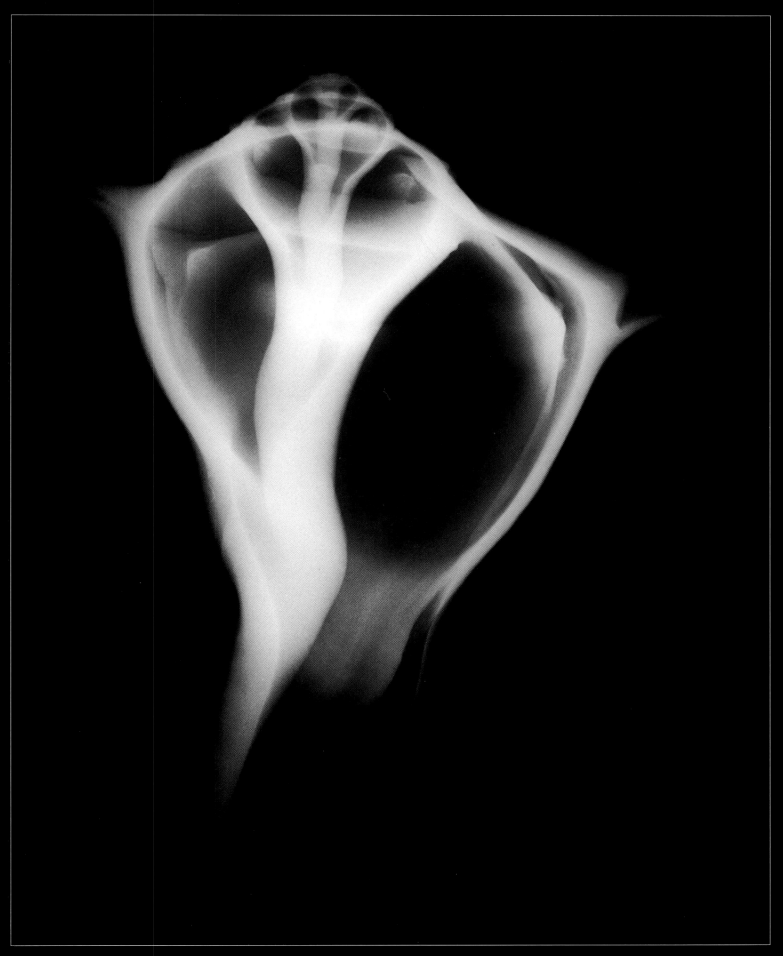

Knobbed Whelk

From Each and All

The delicate shells lay on the shore;
The bubbles of the latest wave
Fresh pearls to their enamel gave,
And the bellowing of the savage sea
Greeted their safe escape to me.
I wiped away the weeds and foam,
I fetched my sea-born treasures home;
But the poor, unsightly, noisome things
Had left their beauty on the shore
With the sun and the sand and the wild uproar.

by Ralph Waldo Emerson (1803–1883)

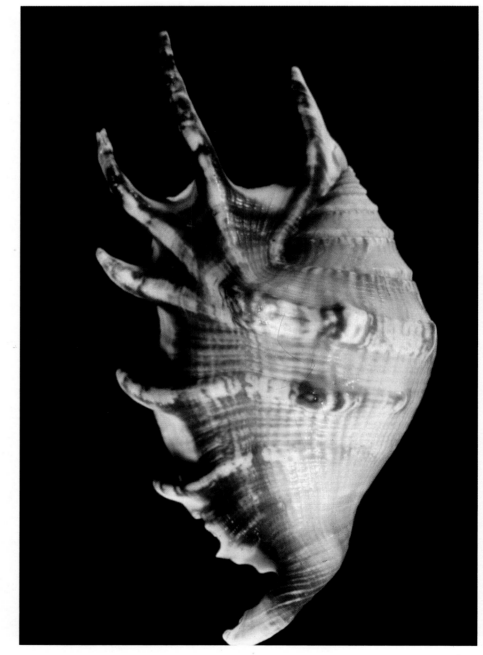

Common Spider Conch
Lambis lambis Linnaeus

A relative of the true conchs, the Common Spider Conch lives in warm,
tropical waters. Seven curved projections emerge from its heavy lip.
10–15 cm. Indo-Pacific. Common.

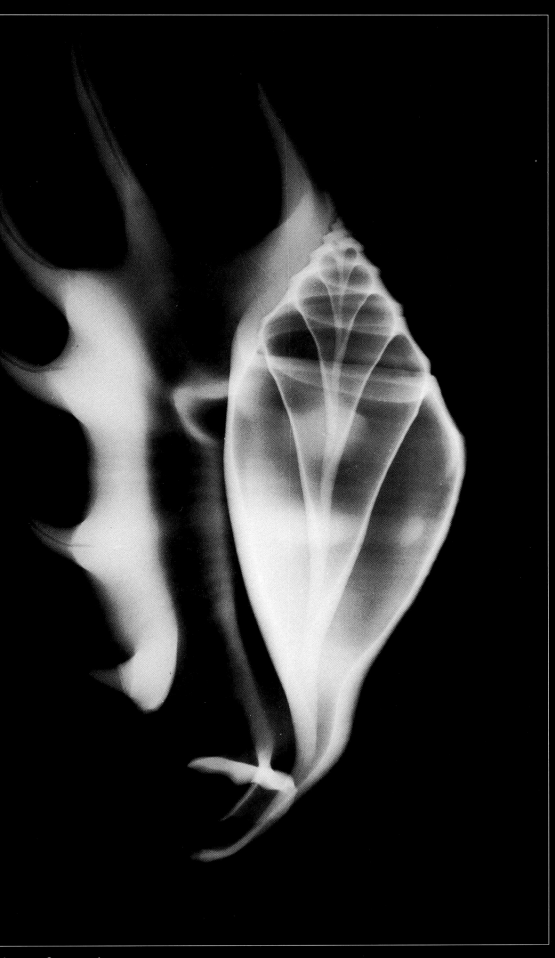

der Conch

On Some Shells Found Inland

These are my murmur-laden shells that keep
A fresh voice tho' the years lie very gray.
The wave that washed their lips and tuned their lay
Is gone, gone with the faded ocean sweep,
The royal tide, gray ebb and sunken neap
And purple midday,—gone! To this hot clay
Must sing my shells, where yet the primal day,
Its roar and rhythm and splendour will not sleep.
What hand shall join them to their proper sea
If all be gone? Shall they forever feel
Glories undone and worlds that cannot be?—
'T were mercy to stamp out this agèd wrong,
Dash them to earth and crunch them with the heel
And make a dust of their seraphic song.

by Trumbull Stickney (1874–1904)

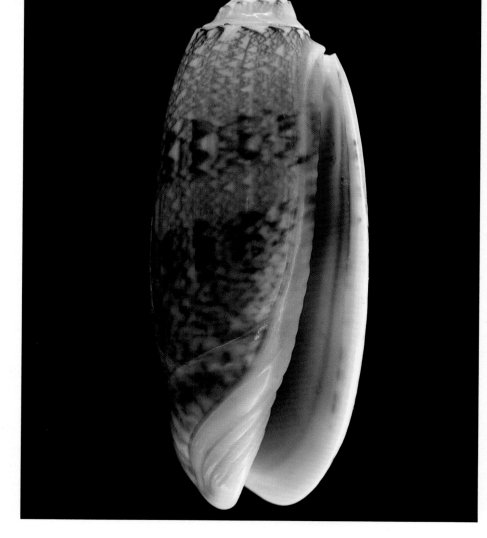

Lettered Olive
Oliva sayana Ravenel

Lettered Olives are northern ambassadors of a widespread tropical family. Like their relatives, Lettered Olives come out of their burrows at night in search of worms, their principal food. The shell remains glossy throughout life because of the fleshy mantle covering it at all times. The Lettered Olive has been adopted as the state shell of South Carolina.

7 cm. Southeast U.S.A. Common.

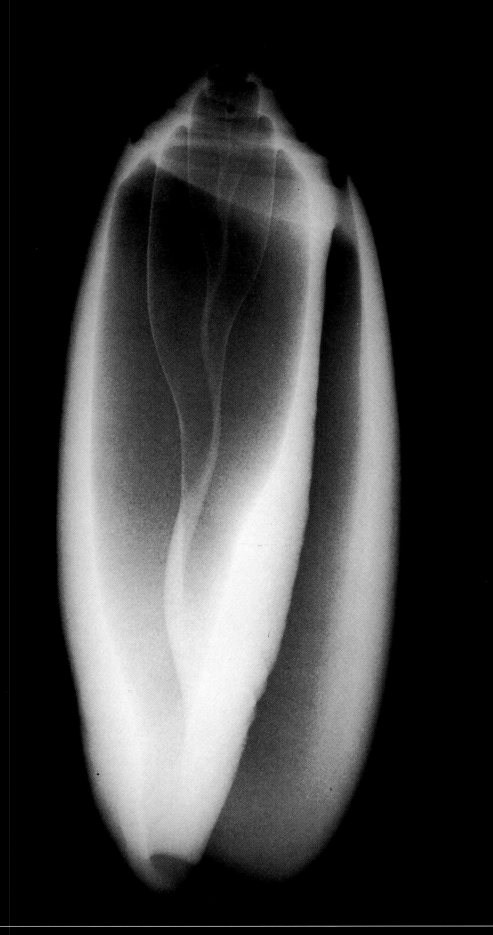

Lettered Olive

The Voice of Many Waters

From

Far away and dreamy
 Was the Voice I heard;
Yet it pierced and found me,
Through the voices round me—
 Song without a word.
All the life and turmoil,
 All the busy cheer
Melted in the flowing
Of that murmur, growing,
 Claiming all my ear.

by Frances Ridley Havergal (1836–1879)

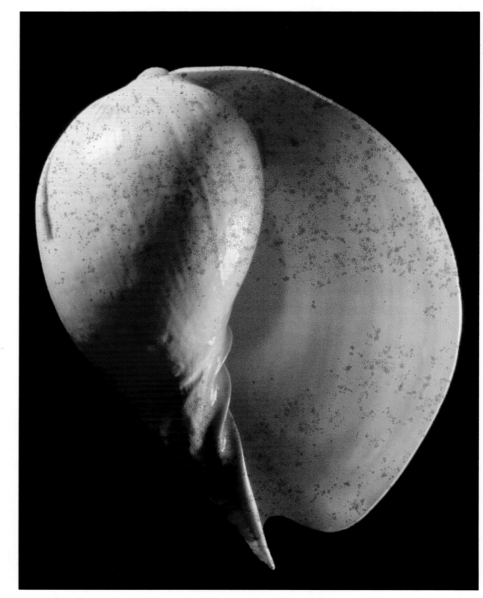

Melon Shell
Melo melo Solander

The most common and widespread member of this large group of volutes. Melon shells get their name from their obvious resemblance to the fruit of the same name. Although Melon and Bailer shells are of the same genus, the characteristic crown of spines that surround the spire of young Bailers is missing in Melon shells. When this spineless spire becomes covered at maturity by the last chorl, called a body whorl, Melon shells appear almost round. Like other volutes, Melons feed on other mollusks and invertebrates.
15–20 cm. Southeast Asia. Frequent.

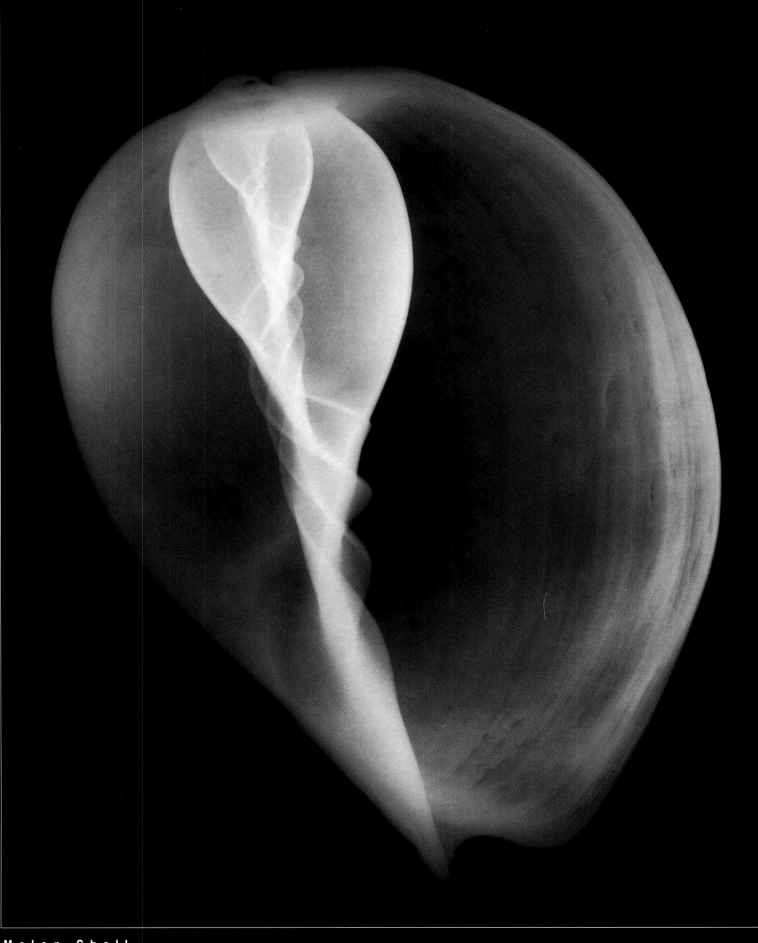

Melon Shell

From Ode to the Statue of a Muse…

Oh for a capable ear, like his who stretched
The chords first on the shell, and what his tongue
Failed to shape forth in words, thence, yearning, fetched,
The music of the World when it was young!
Oh for a hearing fine as his who, blind,
Caught, with the larger senses of the soul,
A region-whisper of the Universe:
 A music too refined
For mortal hearing; of which none the whole
E'er heard, or what he hears can e'er rehearse!
Listen! Methinks a murmur, such as throngs
The spiral windings of the sea-tuned shell
With ocean-echoes and faint Mermaid-songs,
Works in mine ear like an enchanter's spell!
Fuller, diviner, on my sense there grows
A deep, sweet melody, that fills all time,
All space: the burthen of six thousand years,
 That past me ever flows
In waves of music, upon which sublime
My heart is floated onward to the spheres!

by Henry Ellison (1811–1890)

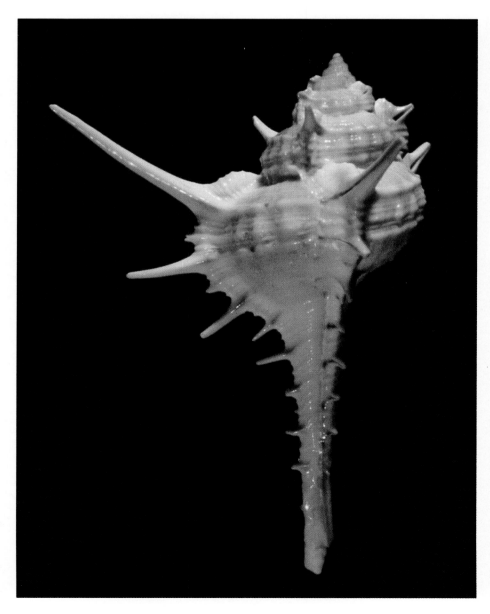

B l a c k - S p i n e d M u r e x
Murex nigrospinosus Reeve

Found mainly in warm, tropical waters, this murex is a member of the
Muricidae family. The shell is characterized by its long, black, tapering spines.
6–8 cm. Indo-Pacific. Frequent.

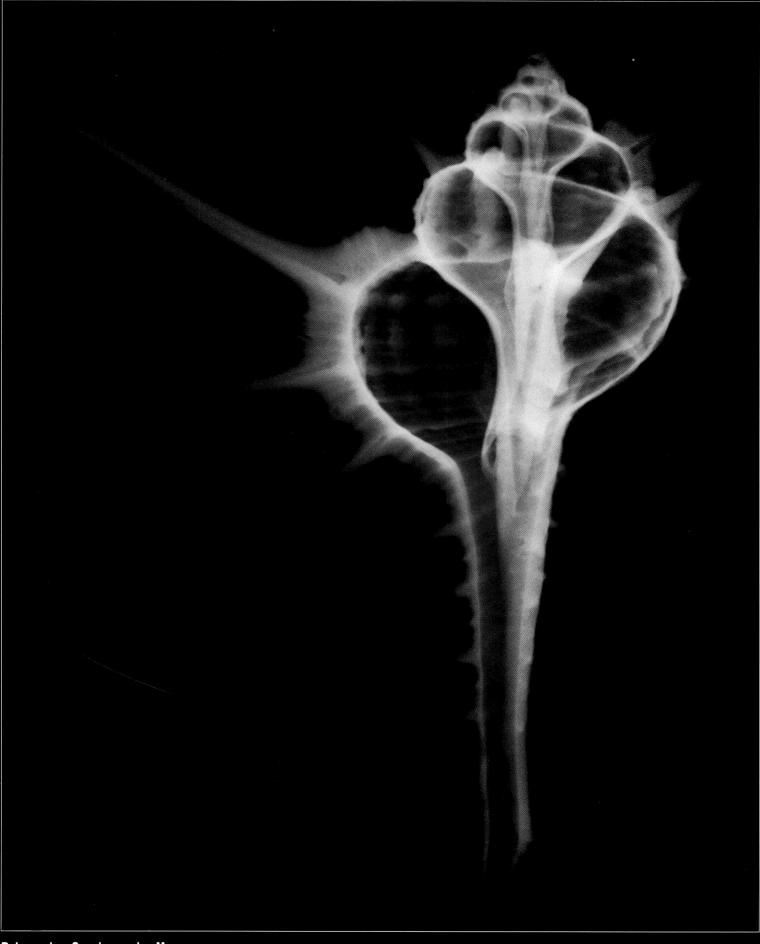

Black-Spined Murex

Appreciation

To the sea-shell's spiral round
'T is your heart that brings the sound:
The soft sea-murmurs that you hear
Within, are captured from your ear.

You do poets and their song
A grievous wrong,
If your own soul does not bring
To their high imagining
As much beauty as they sing.

by Thomas Bailey Aldrich (1836–1907)

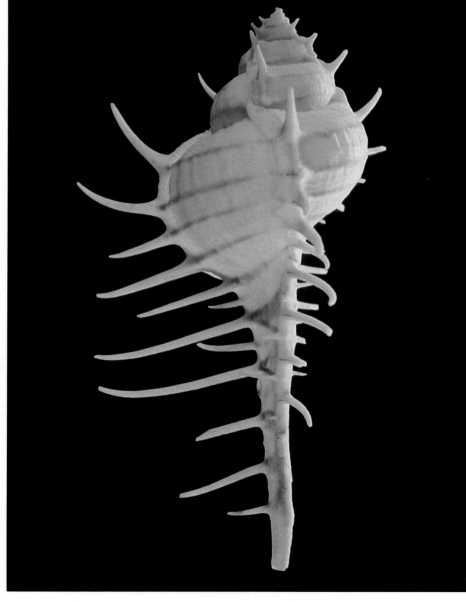

Woodcock Murex

Murex scolopax Dillwyn

This moderately large shell has a long siphonal canal and curved spines.
10 cm. Indo-Pacific. Uncommon.

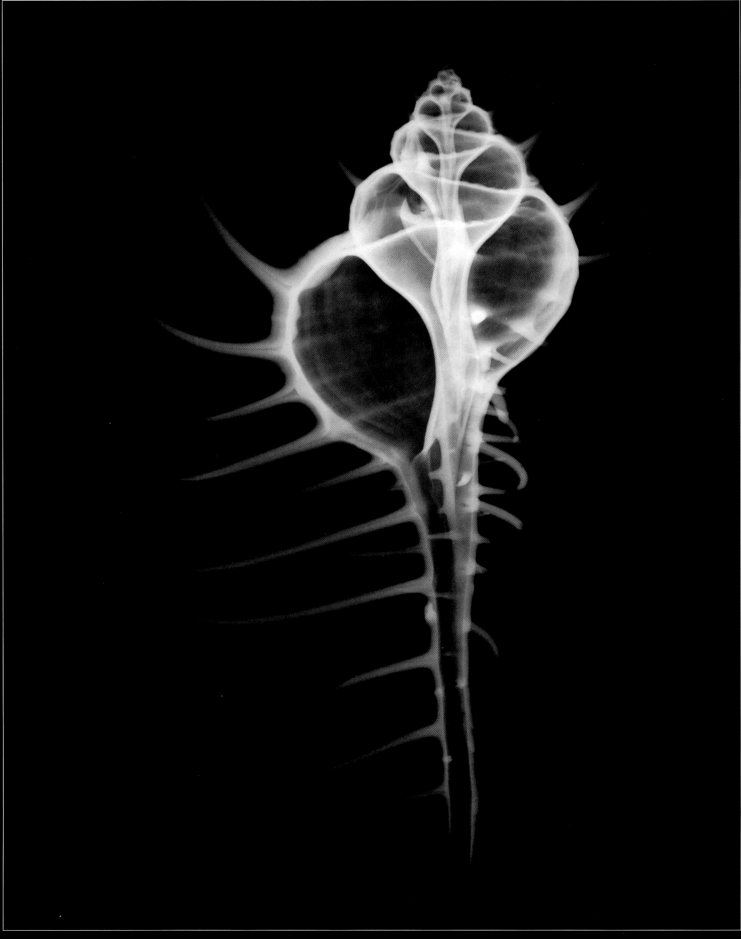

Woodcock Murex

From
Does the Pearl Know?

Does the pearl know, that in its shade and
 sheen,
The dreamy rose and tender wavering
 green,
 Are hid the hearts of all the ranging seas,
 That Beauty weeps for gifts as fair as
 these?
Does it desire aught else when its rare
 blush
Reflects Aurora in the morning's hush,
 Encircling all perfection can bestow,
 Does the pearl know?

by Helen Hay (1875–1944)

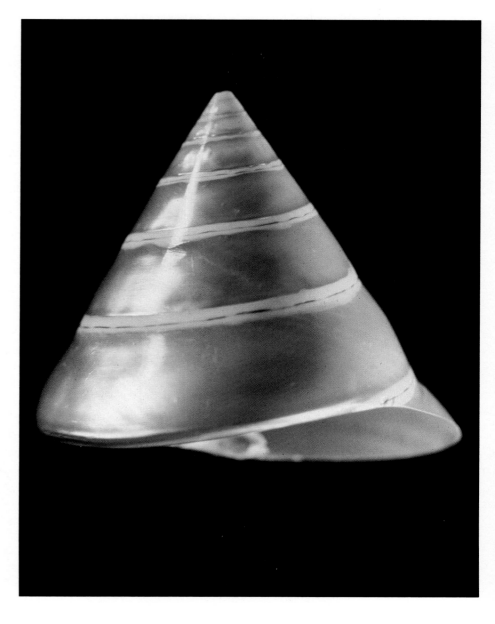

Pearl Trochus
Tectus niloticus Linnaeus

An important commercial species, this large member of the herbivorous top and turban family is colored a contrasting black and white in life. After harvesting, the animal is removed and the shell treated with acid. This treatment removes the outer layer and exposes the shiny mother-of-pearl, called nacre, which is then cut into buttons and other small ornaments. An important species within its range, it is commercially raised in some areas to increase production and quality while reducing losses due to predation.
5–13 cm. Indo-Pacific. Common.

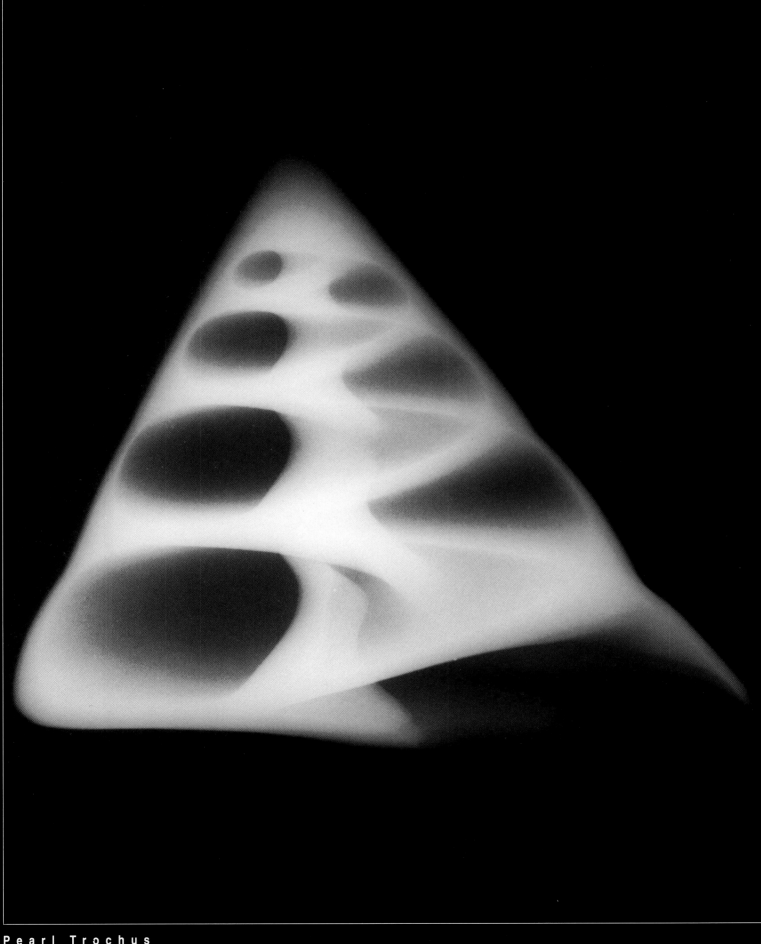

Pearl Trochus

All Things Bright and Beautiful

All things bright and beautiful,
All creatures great and small,
All things wise and wonderful,
The Lord God made them all.

by Cecil Frances Alexander

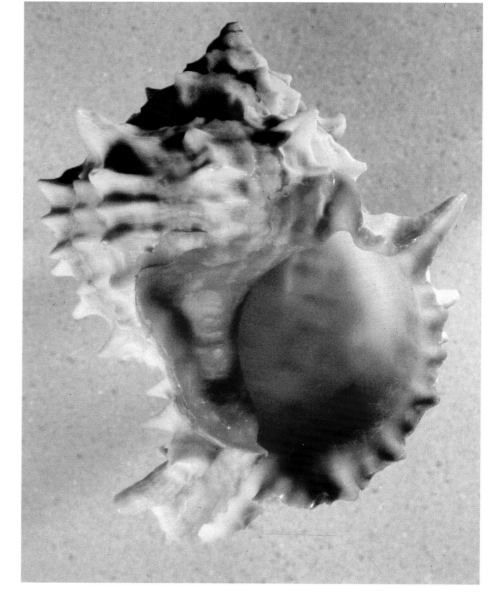

P i n k - M o u t h e d M u r e x
Murex erthrostoma Swainson

The most abundant murex of western South America, the Pink-Mouthed
Murex lives in shallow subtidal water where it feeds on large clams. The
predominance of only pink and white in its color scheme provided the basis
for the now obsolete scientific name, Murex bicolor. Thousands of speci-
mens are collected in baited traps or by hand for export as curios, an
activity which apparently has had little effect on their overall numbers.
7–15 cm. Mexico-Peru. Common.

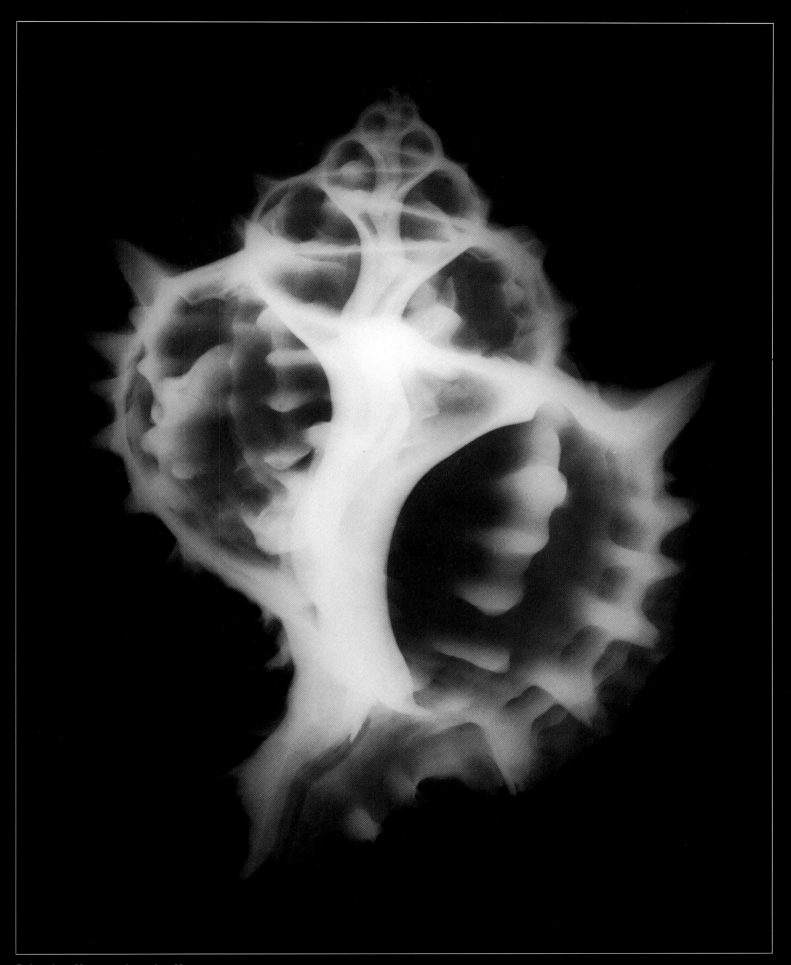

Pink-Mouthed Murex

Sonnet XCVII
A Superscription

Look in my face; my name is Might-have-been;
 I am also called No-more, Too-late, Farewell;
 Unto thine ear I hold the dead-sea shell
Cast up thy Life's foam-fretted feet between;
Unto thine eyes the glass where that is seen
 Which had Life's form and Love's, but by my spell
 Is now a shaken shadow intolerable,
Of ultimate things unuttered the frail screen.

Mark me, how still I am! But should there dart
 One moment through thy soul the soft surprise
 Of that winged Peace which lulls the breath of sighs—
Then shalt thou see me smile, and turn apart
Thy visage to mine ambush at thy heart
 Sleepless with cold commemorative eyes.

by Dante Gabriel Rosetti (1828–1882)

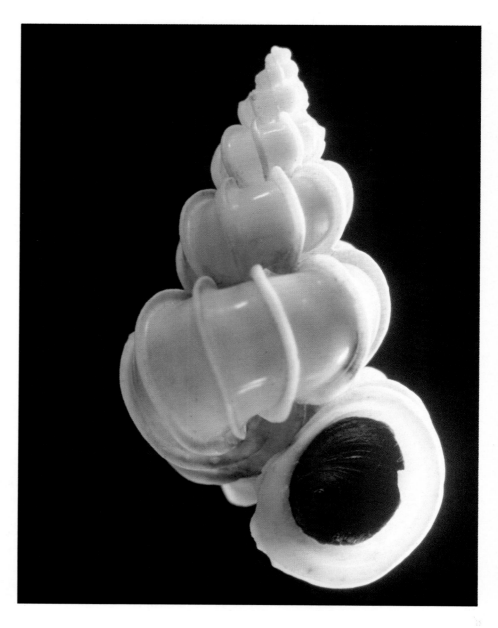

Precious Wentletrap
Epitonium scalare Linnaeus

Perhaps the best known of wentletraps is the Precious Wentletrap of Japan. It was first found in the late 1700s and brought to Europe by the Dutch. During the last century, its value has induced people to make rice-paste and porcelain counterfeits, an ironic twist of fate which today makes these fakes more valuable than the now uncommon shell. *3.5–6.0 cm.*

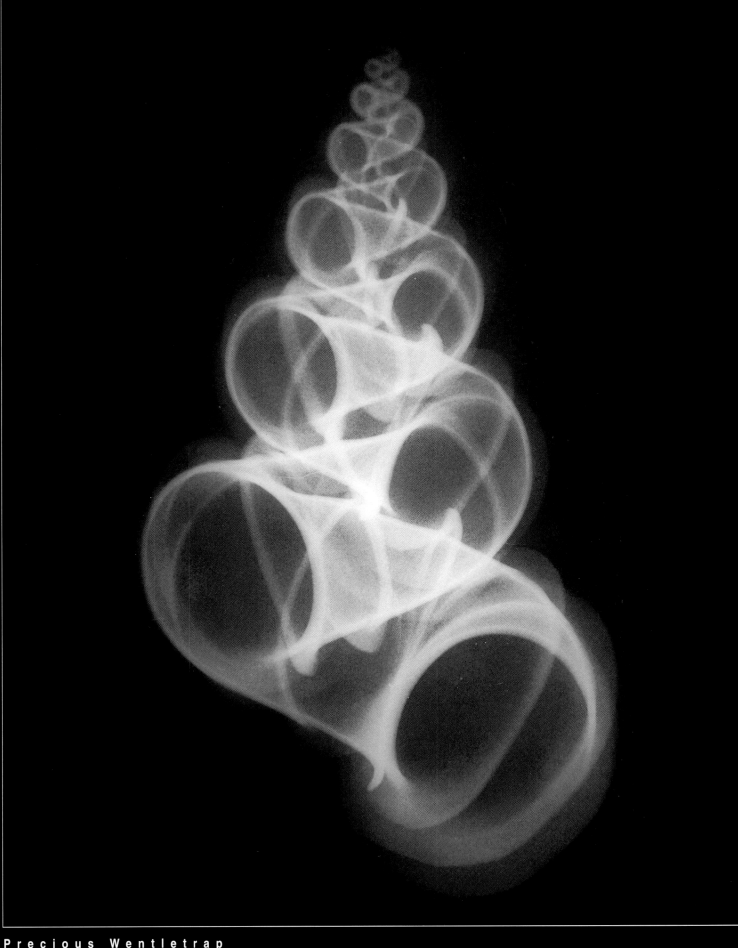

Precious Wentletrap

From **A** Tale of Eternity

As chalk is formed at bottom of the sea
From life that sheds it shell continually;
As bones are built up out of life's decay,
The body is shaped of substance sloughed away
From soul in ripening: 'tis a husk which yields
The earthy scaffold whereby spirit builds
Its heavenly house, that stands when the world crust
Is made of dropt and perisht human dust.

by Gerald Massey (1828–1907)

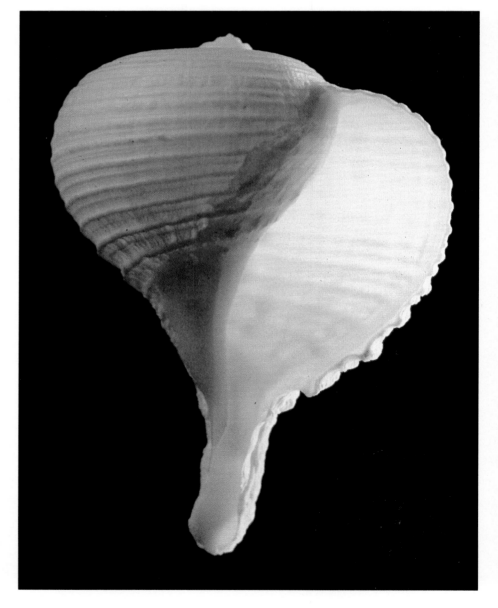

Papery Rapa

Rapa rapa Linnaeus

Exquisite in design but with a paperlike structure, the
Papery Rapa lives in the soft coral of the Philippines.
8 cm. Indo-Pacific. Common.

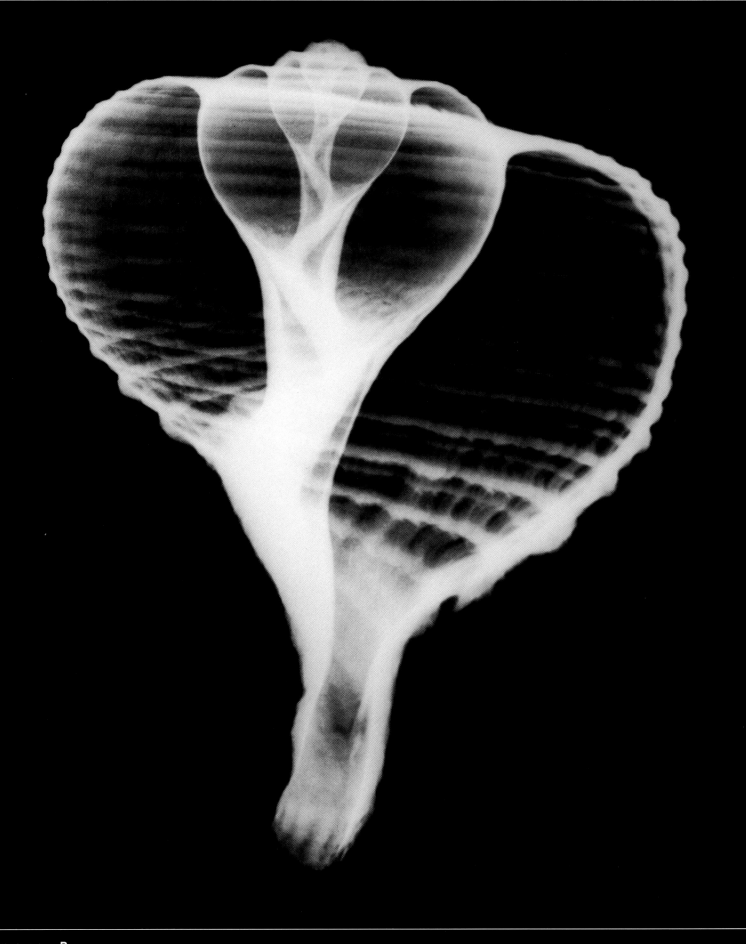

Papery Rapa

From Mundorum Explicatio

So see in Man his outward case doth hide
A noble Soul; Which doth more inward bide.
This outward World is as the crust, or shell,
In which the other Light, and Dark Worlds dwell.

by Samuel Pordage (1633–1691?)

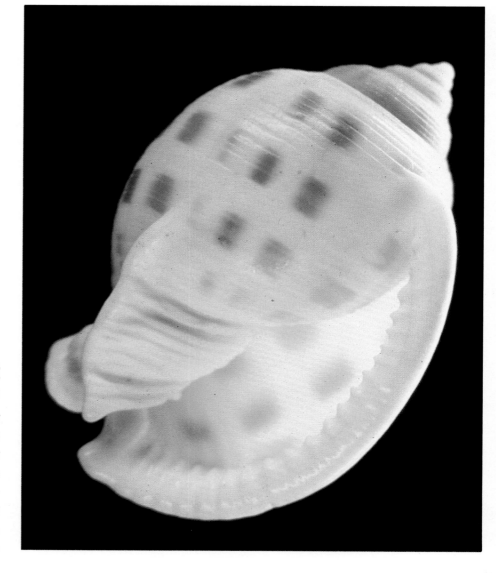

S c o t c h B o n n e t
Phalium granulatum Born

The Scotch Bonnet is common to the South Florida beaches. Another population is found on the North Carolina shores and has been named the official shell of that state. Scotch Bonnets are related to the much larger helmets, and, like the latter, feed primarily on sea urchins. Similar species are found along the West Coast of Africa and Panama's Pacific Coast—supporting the theory of a continuous population once linked by closer continents and a disconnected South American land mass.
6–10 cm. North Carolina-Caribbean. Common.

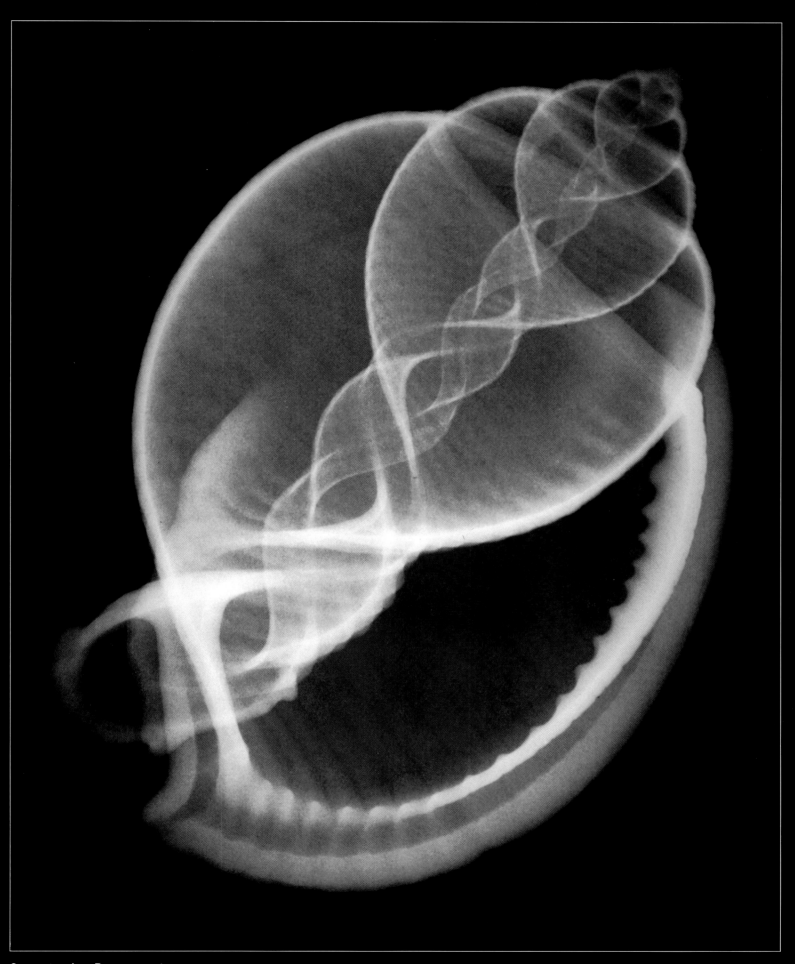

Scotch Bonnet

From Litany

Wheel and windle, spool and spindle, let them weave and spin;
Let them wind us what assigned us is, day out, day in.
Sweet and bitter, gold and flitter, all must have its day;
Little matter on Life's platter what for us they lay.

by John Payne (1842–1916)

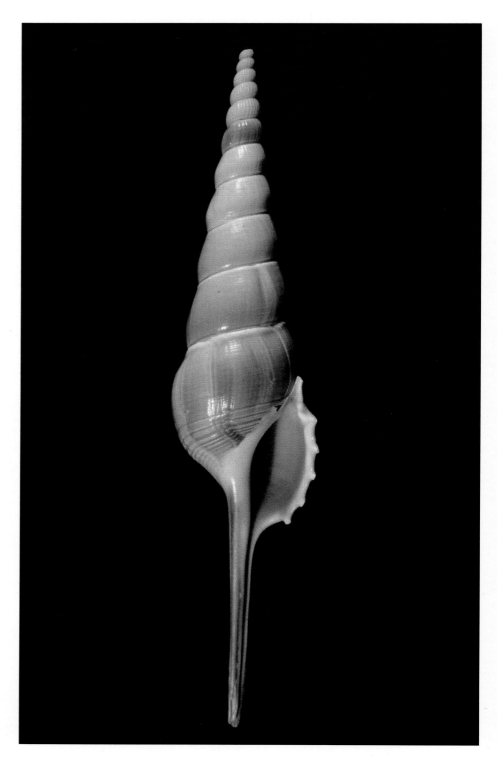

Spindle Tibia
Tibia fusus Linnaeus

The unusually shaped Spindle Tibia is actually related to the
herbivorous conchs. Found in rather shallow seas, the long siphonal
canal protects the animal while moving along abrasive substrates.
16–30 cm. Indo-Pacific. Uncommon.

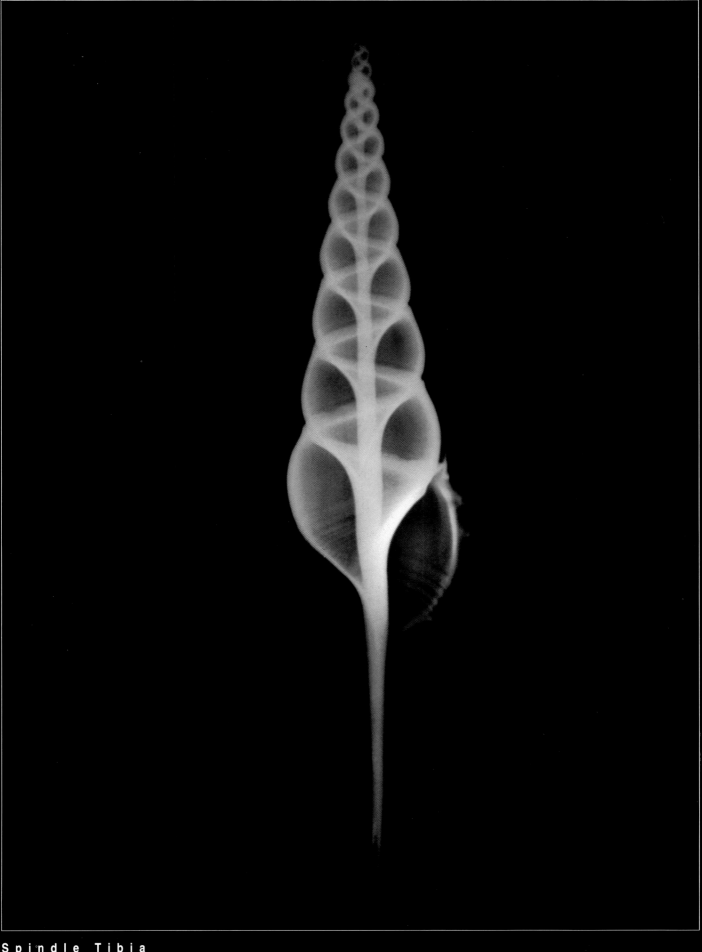

Spindle Tibia

Twilight at Sea

The twilight hours like birds flew by,
As lightly and as free;
Ten thousand stars were in the sky,
Ten thousand on the sea;
For every wave with dimpled face,
That leaped upon the air,
Had caught a star in its embrace,
And held it trembling there.

by Amelia C. Welby (1819–1852)

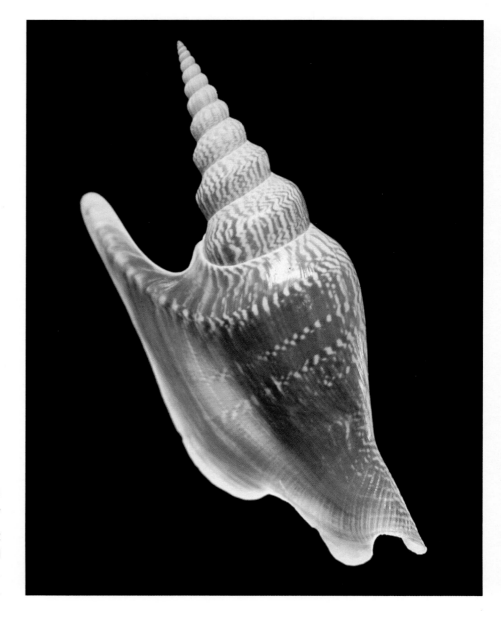

Lister's Conch
Strombus listeri T. Gray

A once-rare species limited to the Indian Ocean. Lister's Conch brought prices exceeding $1,000 only ten years ago. Today they are considered common because offshore trawlers located their preferred habitat.
10–13 cm. Indo-Pacific. Common.

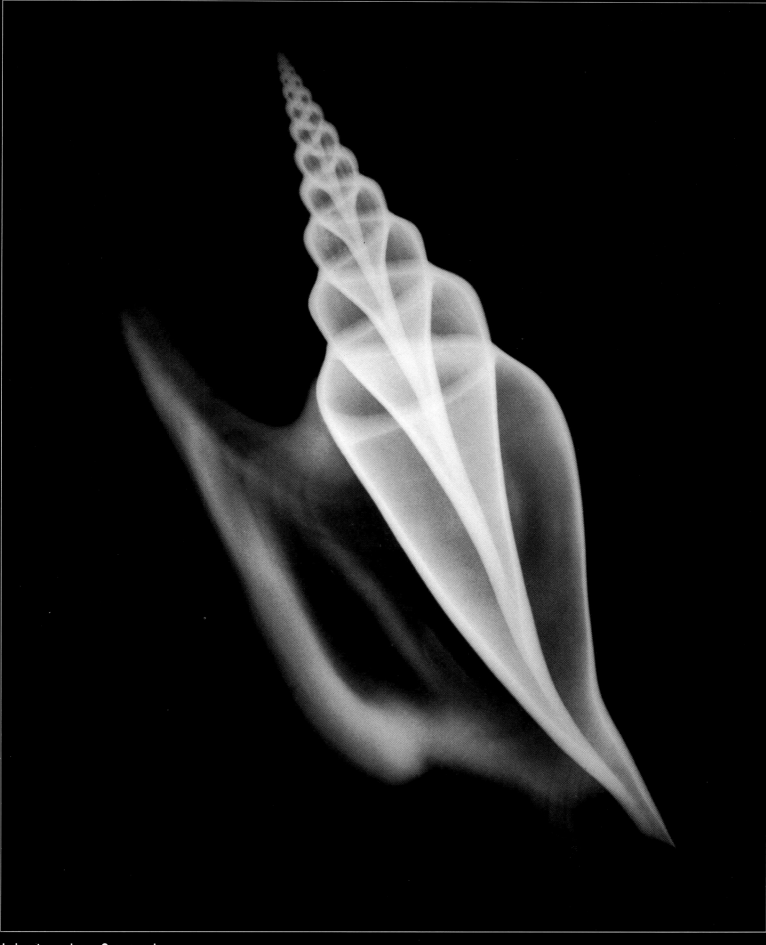

Lister's Conch

From Ode: Intimations of Immortality

Our birth is but a sleep and a forgetting:
The Soul that rises with us, our life's Star,
 Hath had elsewhere its setting,
 And cometh from afar:
 Not in entire forgetfulness,
 And not in utter nakedness,
But trailing clouds of glory do we come
 From God, who is our home…

by William Wordsworth (1770–1850)

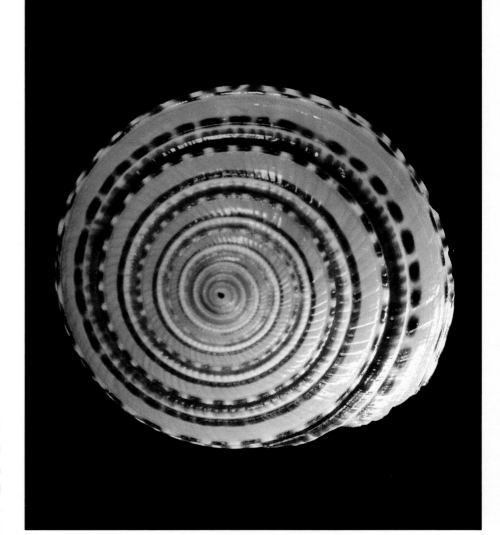

Sundial
Architectonica maxima Roding

Sundials are many-ribbed shells wound around a wide
and open spire. Found in warm seas worldwide, Sundials feed
largely on Sea Pansies, Renillia, a soft-bodied relative of the corals.
5–6 cm. Indo-Pacific. Frequent.

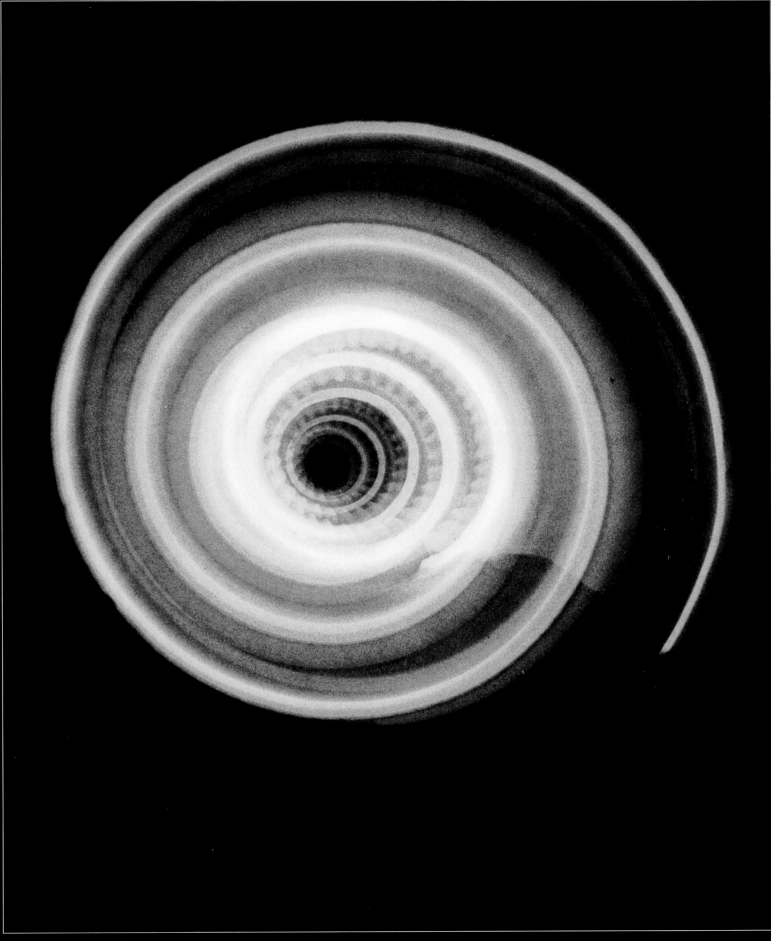

S u n d i a l

From Records

I've seen a Poet on the dreamy shore—
The ocean in deep slumber at his feet,
With scarce the motion of a sleeper's breast,
The full moon lapping all in milky light,
He, like a statue, staring into her—
Become, methought, so lustrous in himself,
That, even in that shiny night, he glow'd
Like palest marble on a ground of black:
And thus he stood, drawing down light from heaven,
Until the moon went out and earth was dark;
Yet he was not; and then it was I saw
The light he drew was not the moon's alone,
But that which flows inside of hers—unseen
Till garner'd in the cumulating soul.

by Robert Leighton (1822–1869)

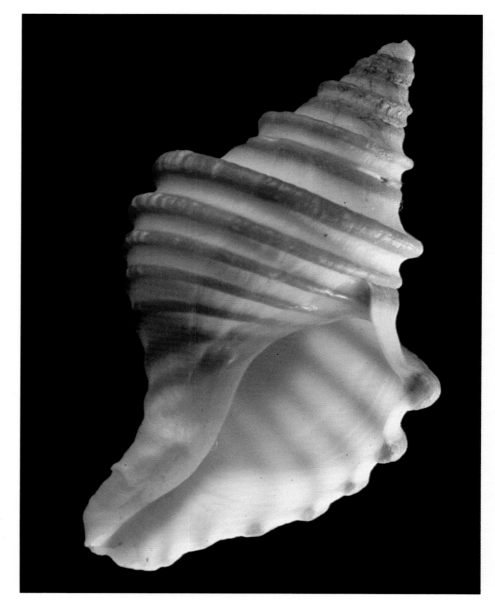

Ten-Ridged Whelk
Neptunea decemcostata Say

A large, stout shell with brown, raised ridges on the body whorl.
Found in cool, moderately shallow water.
7–10 cm. Nova Scotia to Massachusetts. Common.

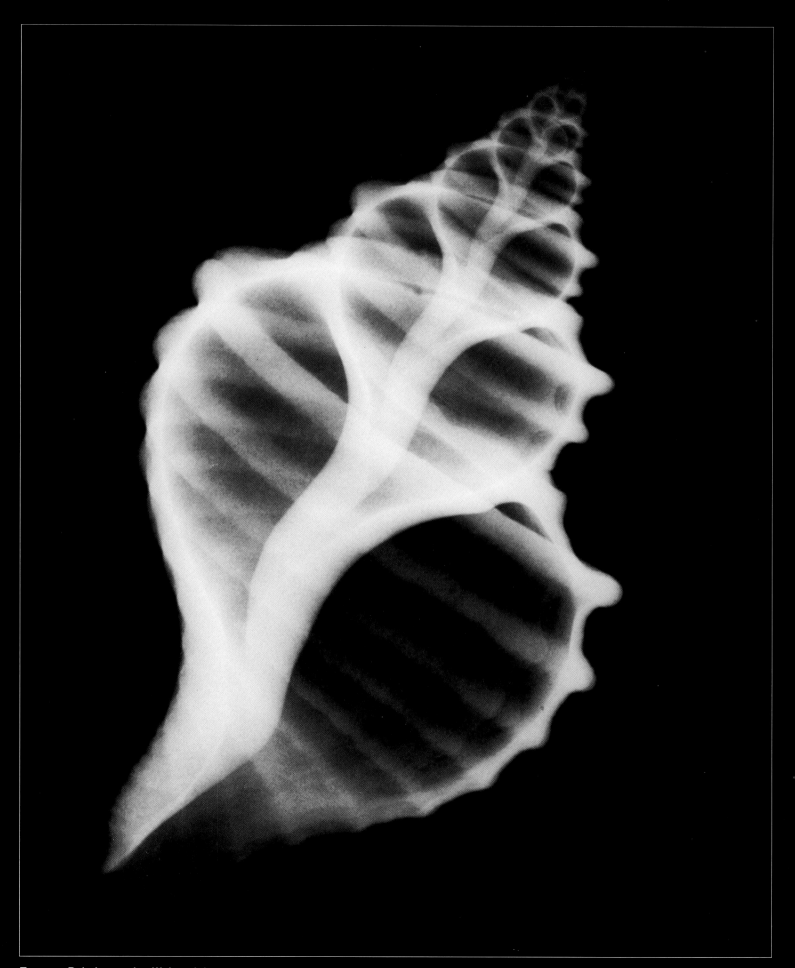

Ten-Ridged Whelk

Sonnet Augustine

Augustine, Scholar, Father, holy Saint,
 Walked by the sounding ocean on the shore,
 Turning in thought grave problems o'er and o'er,
To which he gave his soul without restraint,
Until it grew with musing sick and faint.
 And as his baffled heart felt sad and sore,
 A child he saw that rose-lipped sea-shell bore,
And fill'd it from the sea with motion quaint,—
 Then taking it when full into his hand,
He carried it in happy childish bliss,
 And emptied it in hole scoop'd in the sand.
"I mean," he said, "to pour the deep in this"—
 "Thus," thought the Saint, "God infinite and grand,
 My finite mind would hold and understand."

by Charles Dent Bell (1875–1941)

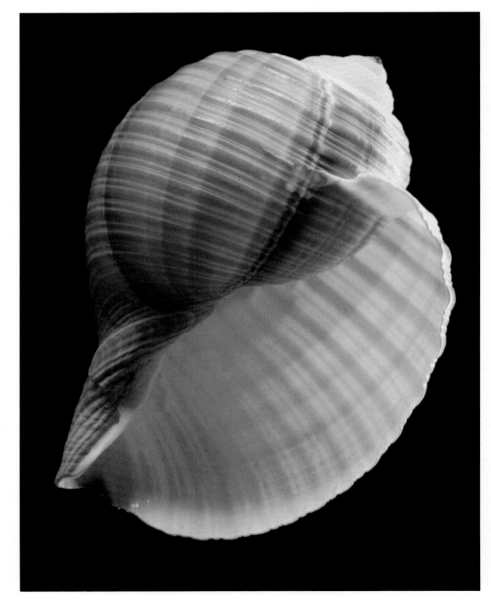

Giant Tun
Tonna galea Linnaeus

Giant Tuns are one of the few mollusks found in warmer areas of both the Atlantic and Pacific Oceans. The fragile-appearing shell is quite sturdy, often washing ashore intact.
6–12 cm. Worldwide; tropical. Frequent.

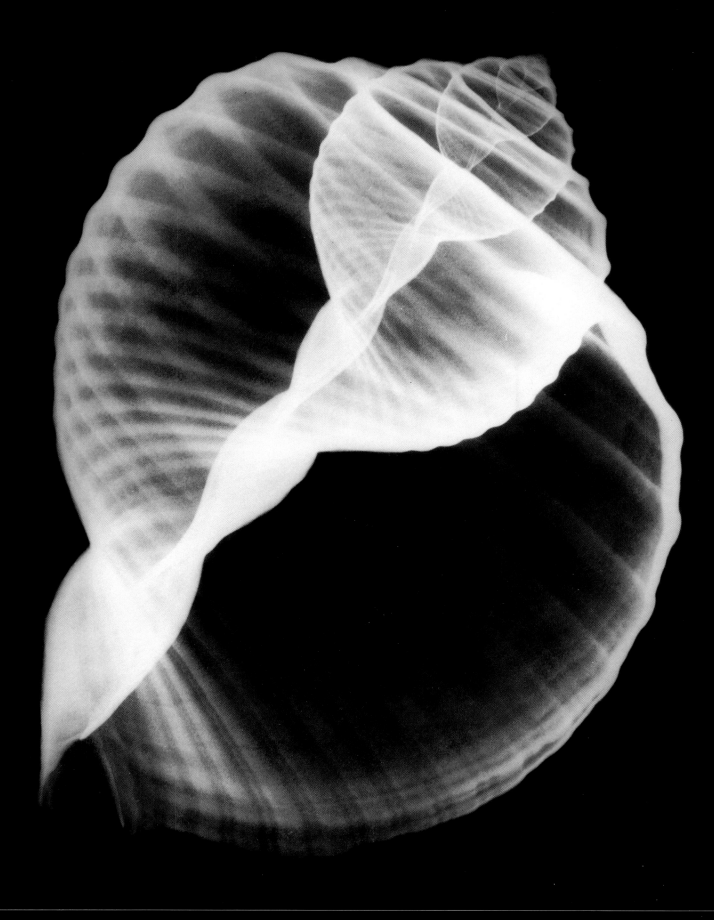

Giant Tun

The World Is Too Much With Us

The world is too much with us; late and soon,
Getting and spending, we lay waste our powers:
Little we see in Nature that is ours;
We have given our hearts away, a sordid boon!
This Sea that bares her bosom to the moon;
The winds that will be howling at all hours,
And are up-gathered now like sleeping flowers;
For this, for everything, we are out of tune;
It moves us not.—Great God! I'd rather be
A Pagan suckled in a creed outworn;
So might I standing on this pleasant lea,
Have glimpses that would make me less forlorn;
Have sight of Proteus rising from the sea;
Or hear old Triton blow his wreathèd horn.

by William Wordsworth (1770–1850)

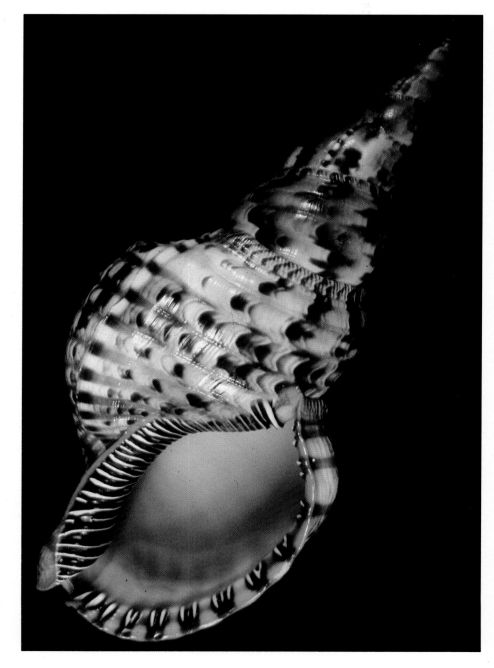

Pacific Triton
Charonia tritonis Linnaeus

One of the largest and most colorful snails in the world.
Since 400 B.C. the Pacific Triton, or Trumpet, has been made into a
horn by cutting off the spire's tip or by drilling a hole in its side. Pacific
Tritons have the distinction of being one of the few animals to feed
on the Crown-of-Thorns starfish that ravages many coral reefs.
15–45 cm. Japan to New Zealand. Frequent.

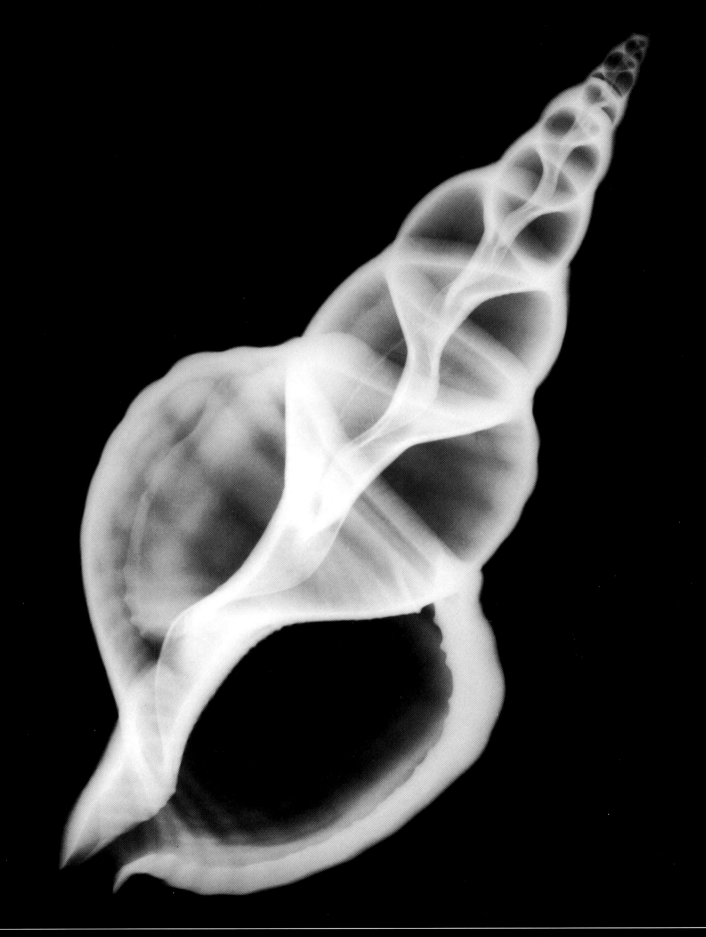

Pacific Triton

fter

I saw her now a spirit bright,
Freed from the weak and mortal frame,
And clad in raiment all of light,
Which flashed like lambent flame.

by Charles Dent Bell (1818–1898)

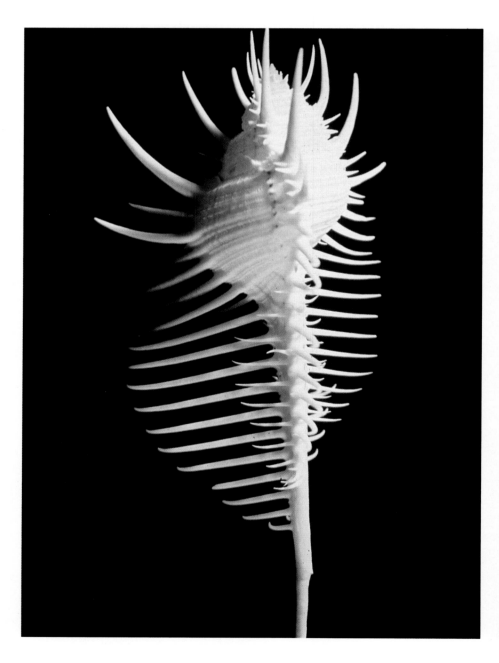

V e n u s C o m b M u r e x

Murex pecten Lightfoot

After examining one of these delicately spined creations, it is hard to
understand how they manage to keep themselves in an unbroken state
during life. The shell and its ornamentations are surprisingly strong, and
many specimens survive the journey from shallow ocean bottoms to
collectors' cabinets. An older name, Murex triremis, likened the shell to the
many-oared warships or Triremes of ancient Mediterranean civilization.
10–15 cm. Indo-Pacific. Common.

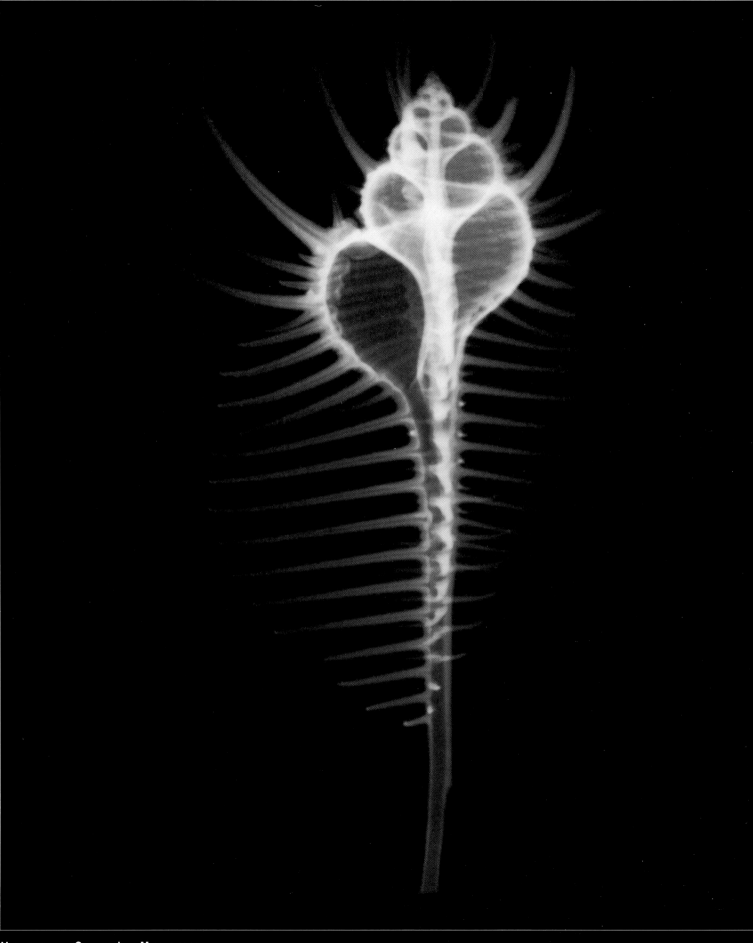

Venus Comb Murex

From

The Builders

All are achitects of Fate,
 Working in these walls of Time;
Some with massive deeds and great,
 Some with ornaments of rhyme.

Nothing useless is, or low;
 Each thing in its place is best;
And what seems but idle show
 Strengthens and supports the rest.

For the structure that we raise,
 Time is with materials filled;
Our to-days and yesterdays
 Are the blocks with which we build.

Truly shape and fashion these;
 Leave no yawning gaps between;
Think not, because no man sees,
 Such things will remain unseen.

by Henry Wadsworth Longfellow (1807–1882)

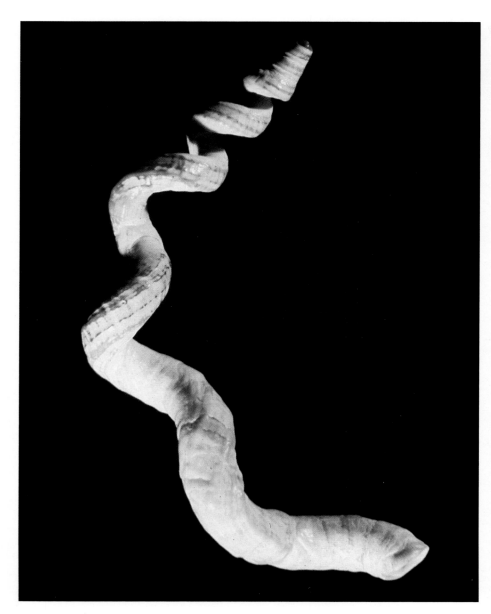

Worm Shell
Vermicularia knorri Deshayes

Appearing as if they had forgotten how to complete their shells, the open-coiled Worm Shells offer a unique approach to shell construction. Some species are colonial, living in masses of undirected tubes that resemble a Medusa-like mass of stationary worms. Others, like Knorr's Worm Shell, live a solitary existence. All worm shells are herbivores and restricted to shallow tropical seas. Knorr's Worm Shell is usually found living inside of sponges.
8 cm. North Carolina to the Gulf of Mexico. Common.

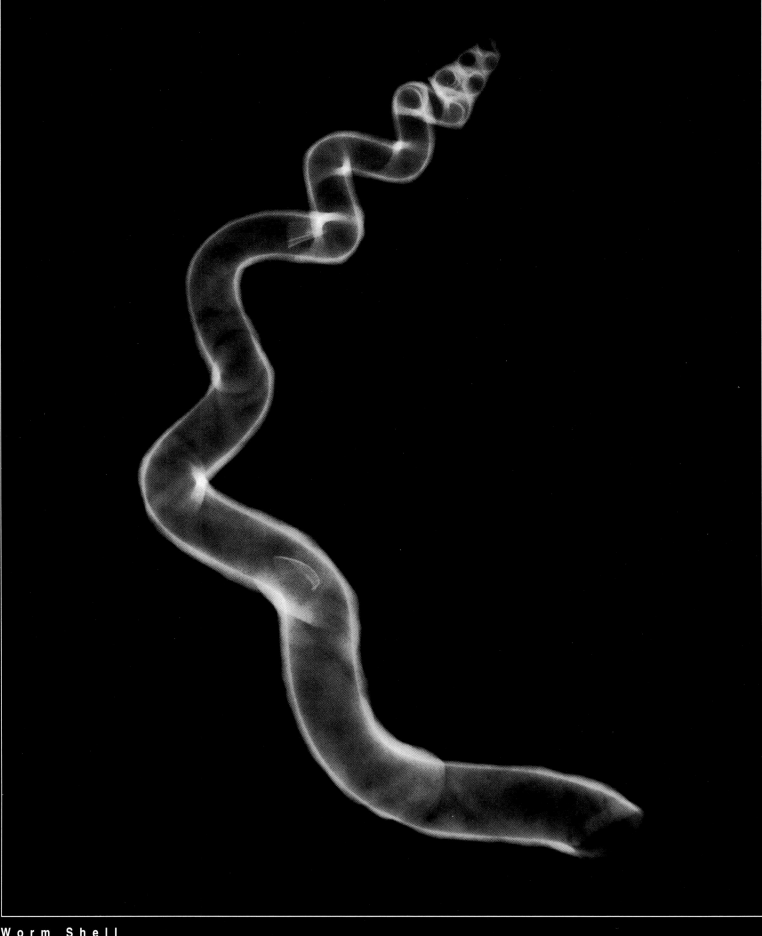

Worm Shell

From
Sonnet Silence

There are some qualities—some incorporate things,
 That have a double life, which thus is made
A type of that twin entity which springs
 From matter and light, evinced in solid and shade.
There is a two-fold *Silence*—sea and shore—
 Body and soul.

by Edgar Allan Poe (1809–1849)

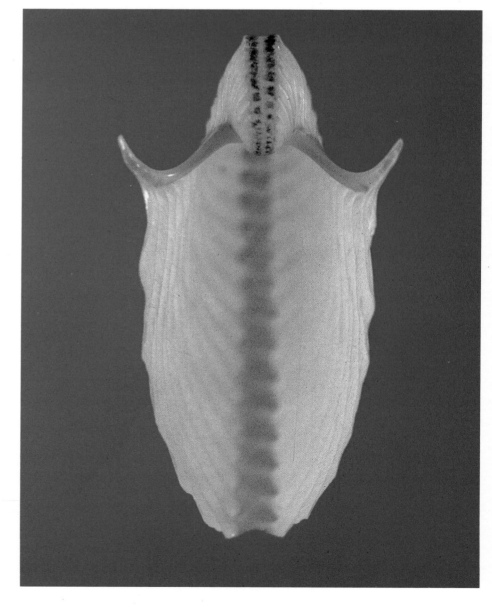

C o m m o n P a p e r N a u t i l u s
Argonauta argo Linnaeus

This is a paper-thin, fragile shell having a double keel with ridges over its surface. The female paper nautilus has arms to protect her eggs. The smaller male makes no shell. Unlike the Chambered Nautilus, the Paper Nautilus has no chambers.
9–12 cm. Worldwide. Common.

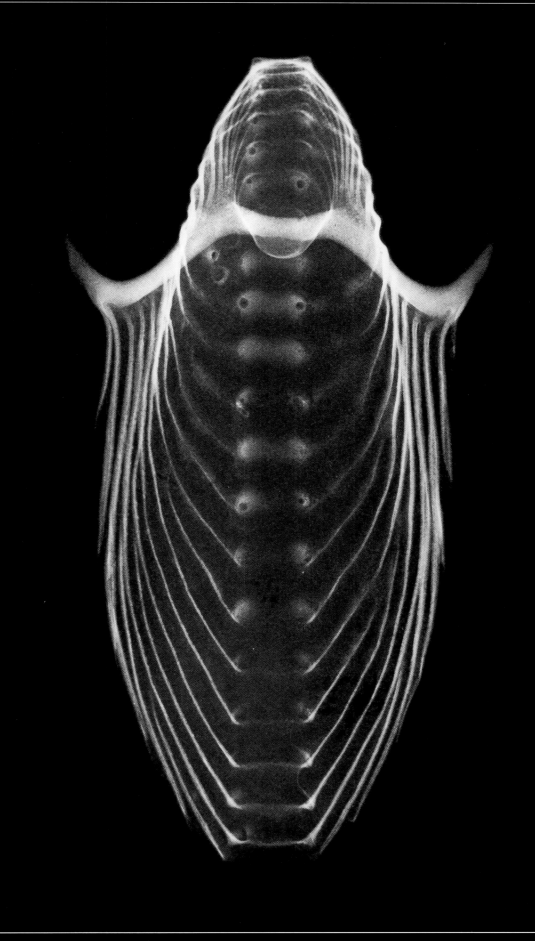

Common Paper Nautilus

From

The Chambered Nautilus

This is the ship of pearl, which, poets feign,
 Sails the unshadowed main,—
 The venturous bark that flings
On the sweet summer wind its purpled wings
In gulfs enchanted, where the siren sings,
 And coral reefs lie bare,
Where the cold sea-maids rise to sun their streaming hair.

Its webs of living gauze no more unfurl;
 Wrecked is the ship of pearl!
 And every chambered cell,
Where its dim dreaming life was wont to dwell,
As the frail tenant shaped his growing shell,
 Before thee lies revealed,—
Its irised ceiling rent, its sunless crypt unsealed!

Year after year beheld the silent toil
 That spread his lustrous coil;
 Still, as the spiral grew,
He left the past year's dwelling for the new,
Stole with soft step its shining archway through,
 Built up its idle door,
Stretched in his last-found home, and knew the old no more.

by Oliver Wendell Holmes (1809–1894)

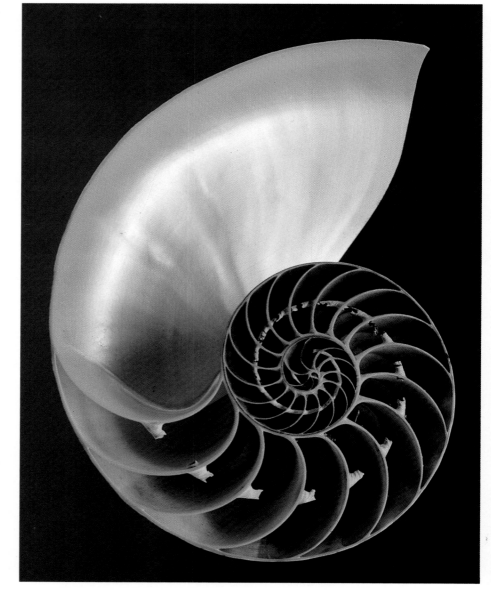

C h a m b e r e d N a u t i l u s

Nautilus pompilius Linnaeus

Often called the "Ship of Pearl," the Chambered Nautilus is one of
the most beautiful and popular of all shells. This sectional view shows
the lustrous mother-of-pearl finish on the interior of the shell as
well as the pores that regulate the gas within each chamber.
15–20 cm. Indo-Pacific. Frequent.

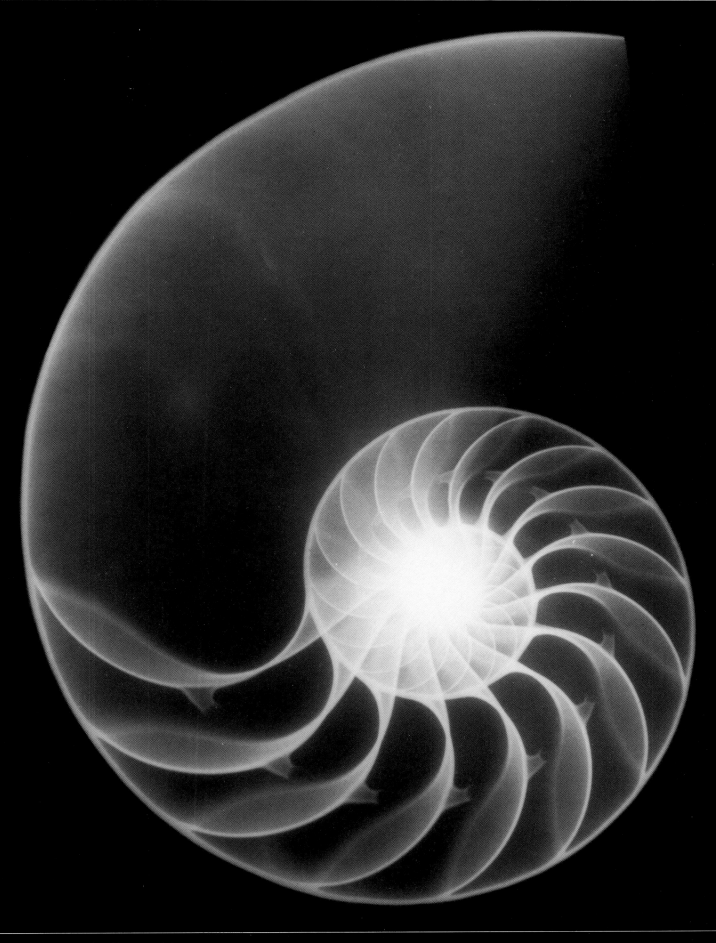

Chambered Nautilus

The Chambered Nautilus

Thanks for the heavenly message brought by thee,
　　Child of the wandering sea,
　　Cast from her lap forlorn!
From thy dead lips a clearer note is born
Than ever Triton blew from wreathéd horn!
　　While on mine ear it rings,
Through the deep caves of thought I hear a voice that sings:—

Build thee more stately mansions, O my soul,
　　As the swift seasons roll!
　　Leave thy low-vaulted past!
Let each new temple, nobler than the last,
Shut thee from heaven with a dome more vast,
　　Till thou at length art free,
Leaving thine outgrown shell by life's unresting sea!

by Oliver Wendell Holmes (1809–1894)

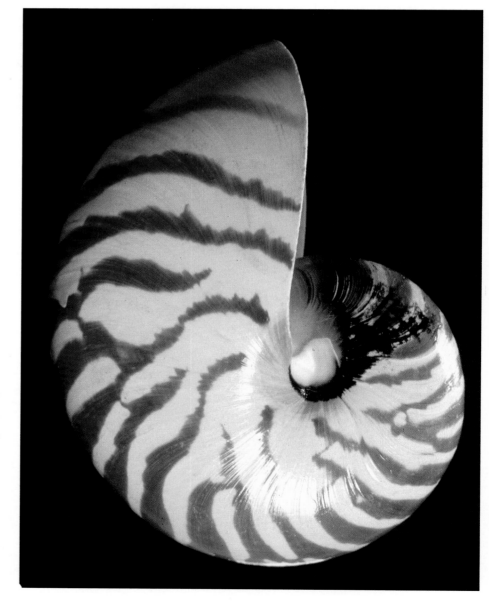

Chambered Nautilus

Nautilus pompilius Linnaeus

The Chambered Nautilus is the only relative of the octopus-squid family with a true shell for protection. The shell on the outside is a creamy white with brownish stripes; within, it has a lustrous mother-of-pearl finish. The shell is composed of gas-filled chambers which are added on as the animal grows. The animal, a member of the Cephalopods family, lives in the last chambers, allowing the animal to dive vertically to great depths without compression breaking open the beautiful shell. The Nautilus can be classified as the forerunner of our modern submarine.
15–20 cm. Indo-Pacific. Frequent.

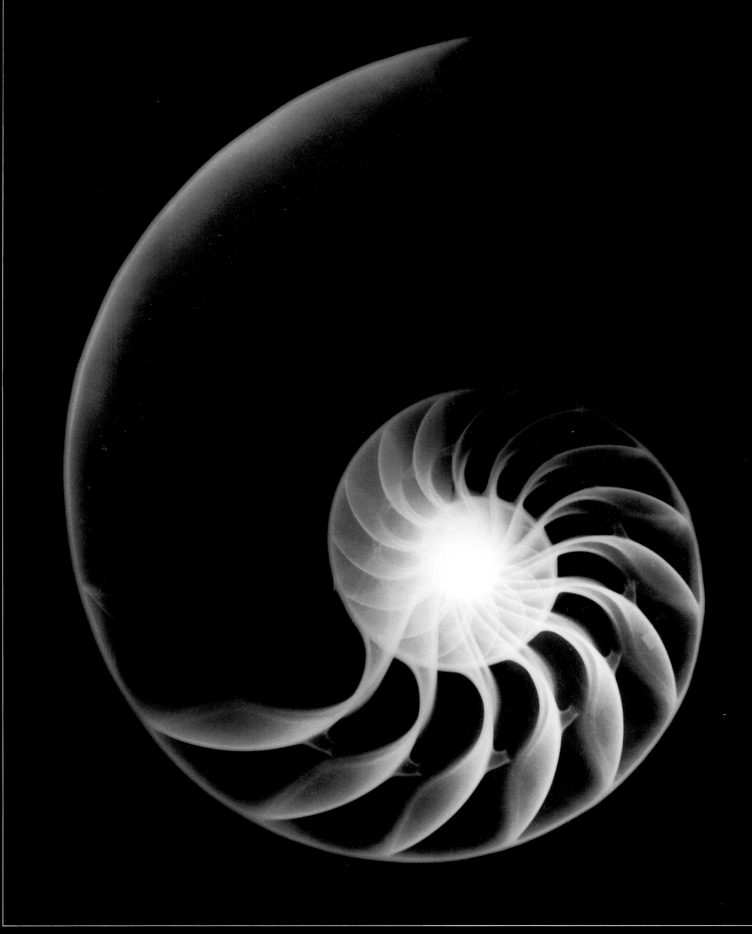

Chambered Nautilus

Memoirs of the Life, Writings, and Discoveries of Sir Issac Newton

I do not know what I may appear to the world; but to myself I seem to have been only like a boy playing on the seashore, and diverting myself in now and then finding a smoother pebble or a prettier shell than ordinary, whilst the great ocean of truth lay all undiscovered before me.

by Sir David Brewster (1781–1868)

S p i r u l a
Spirula spirula Linnaeus

The coiled shell of the Spirula is actually the inner skeleton of this small squid-like animal. Internally, this shell is partitioned into individual chambers that control the animal's buoyancy. Spirulas are rarely seen alive because of the extreme depths (100-200 meters) in which they live. At death, however, the animal's flotation system fails and they come to the surface where currents frequently cast the empty shells onto nearby beaches.
2-3 cm. Worldwide in warm and tropical seas. Common.

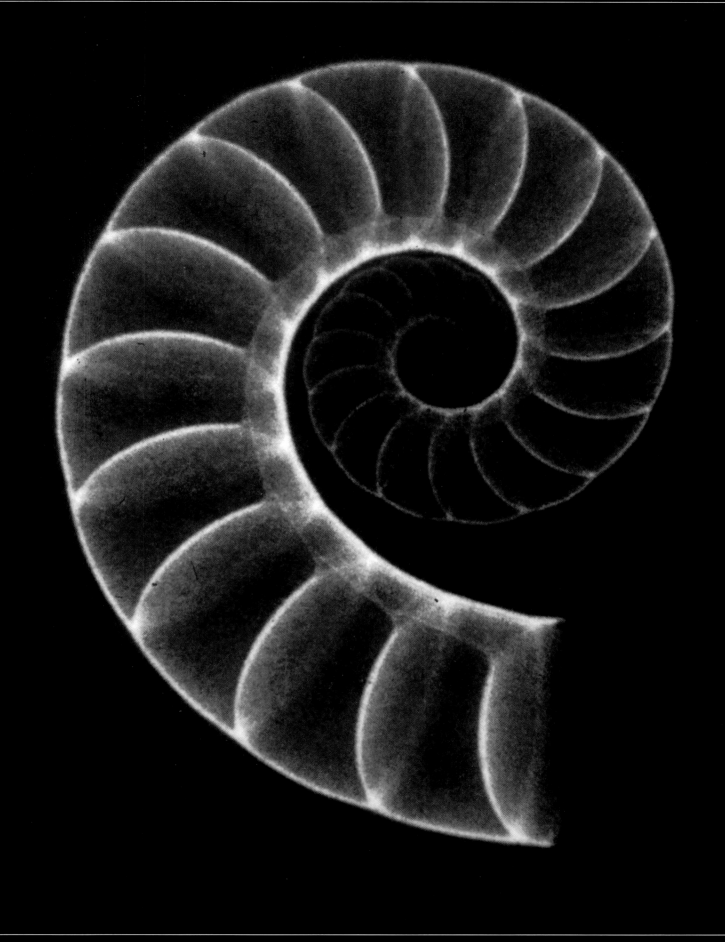

Spirula

From
Elegy Written in a Country Church Yard

Full many a gem of purest ray serene
 The dark unfathom'd caves of ocean bear:
Full many a flower is born to blush unseen,
 And waste its sweetness on the desert air.

by Thomas Gray (1716–1771)

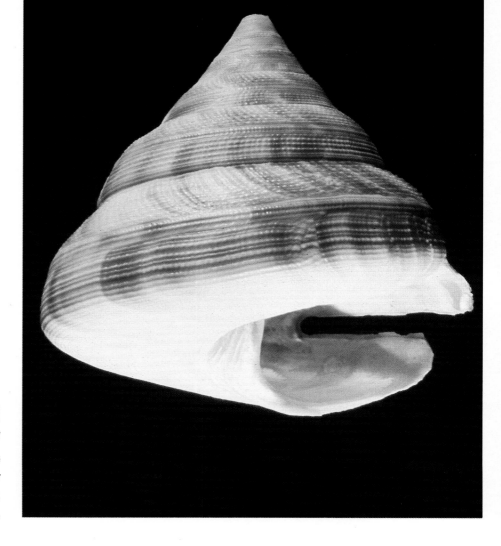

Emperor's Slit Shell
Perotrochus hirasei Pilsbry

The most primitive of the living gastropods, slit shells are characterized by an open groove through which they exhale. Like other members of this worldwide family, they are found only in deep water. *8–12 cm. Japonic. Rare.*

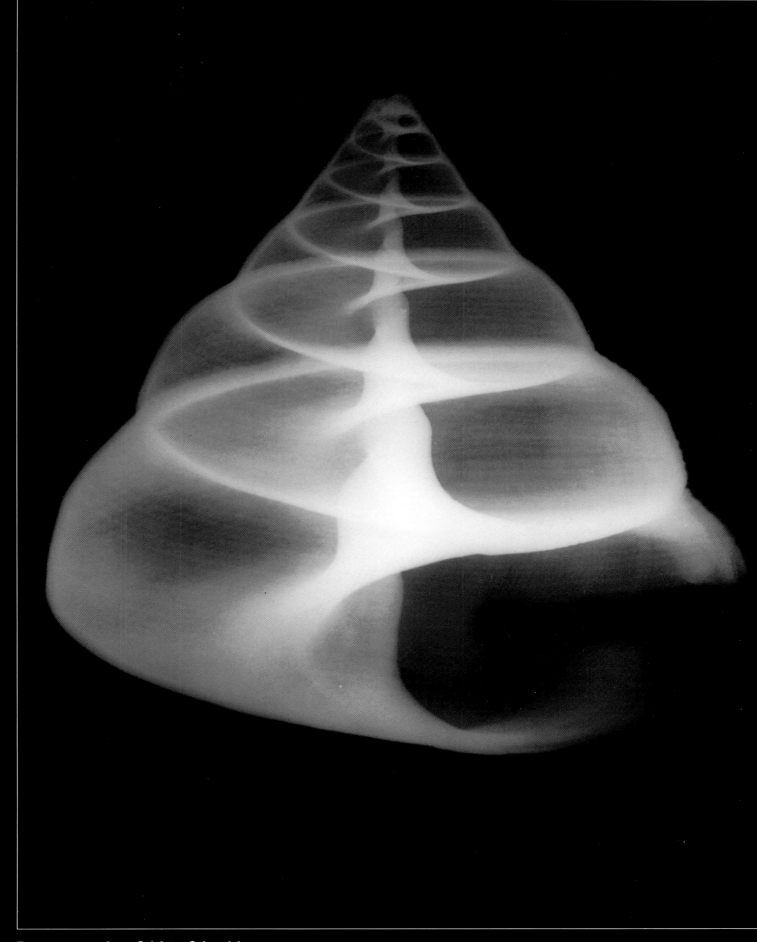

Emperor's Slit Shell

In Memoriam

From

Our little systems have their day;
 They have their day and cease to be;
 They are but broken lights of thee,
And thou, O Lord, art more than they.

We have but faith: we cannot know,
 For knowledge is of things we see;
 And yet we trust it comes from thee,
A beam in darkness: let it grow.

Let knowledge grow from more to more,
 But more of reverence in us dwell;
 That mind and soul, according well,
May make one music as before,

But vaster. We are fools and slight;
 We mock thee when we do not fear:
 But help thy foolish ones to bear;
Help thy vain worlds to bear thy light.

———————— ❧ ————————

by Alfred, Lord Tennyson (1809–1892)

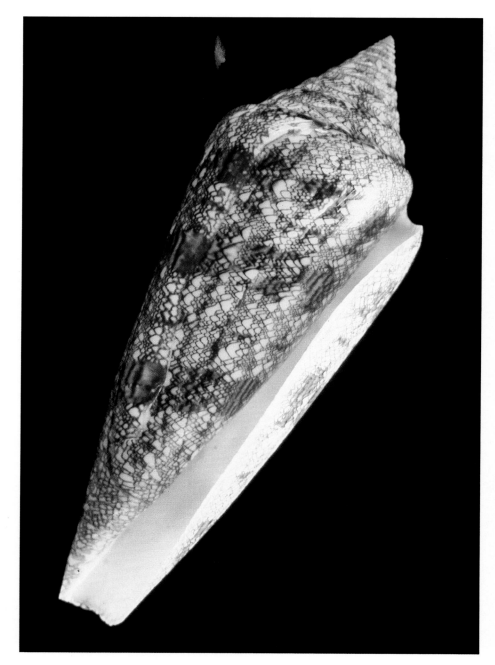

Glory-of-the-Sea
Conus gloria maris Chemnitz

Because of its rarity and beauty, this exquisite shell is a collector's dream. A book, *The Glory of the Sea*, was published in 1887. A specimen was stolen in 1951 from an exhibit in the American Museum of Natural History; it was never recovered. Through private dealers and auctions, excellent specimens once sold for as much as $2,000; today they cost much less. Like other cone shells, the Glory-of-the-Sea is carnivorous, feeding on worms and small fish. It attacks its prey with a poison-tipped harpoon (located in its radula sac) which can render a victim almost twice its size completely paralyzed in eighteen seconds.
7–14 cm. Philippines, Indonesia, Admiralty Islands. Rare.

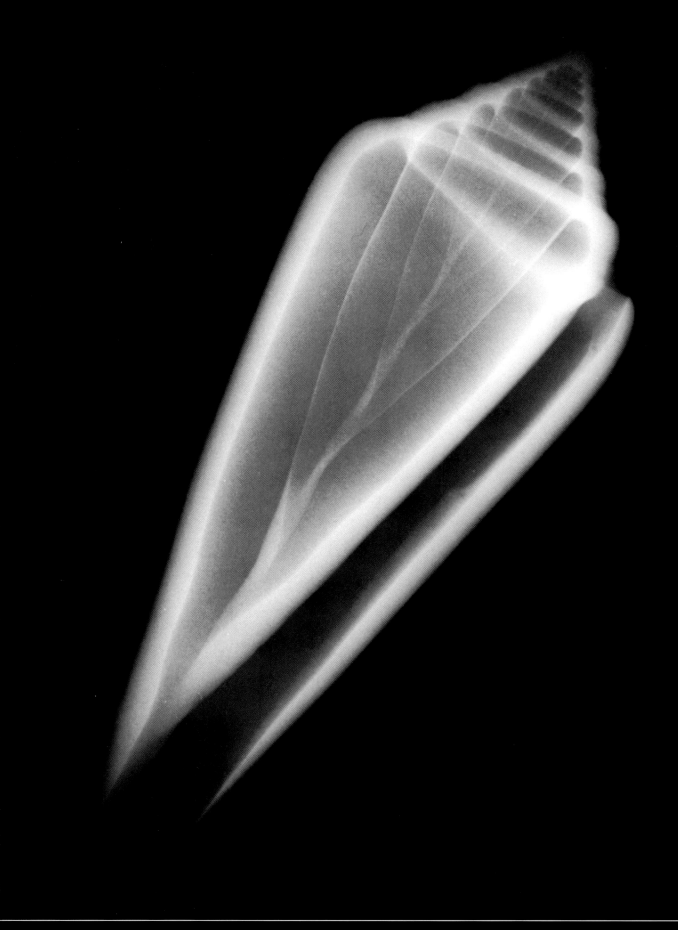

Glory-of-the-Sea

From Essay on Criticism

First follow Nature, and your judgment frame
By her just standard, which is still the same;
Unerring Nature, still divinely bright,
One clear, unchanged, and universal light,
Life, force, and beauty must to all impart,
At once the source, and end, and test of art.

by Alexander Pope (1688–1744)

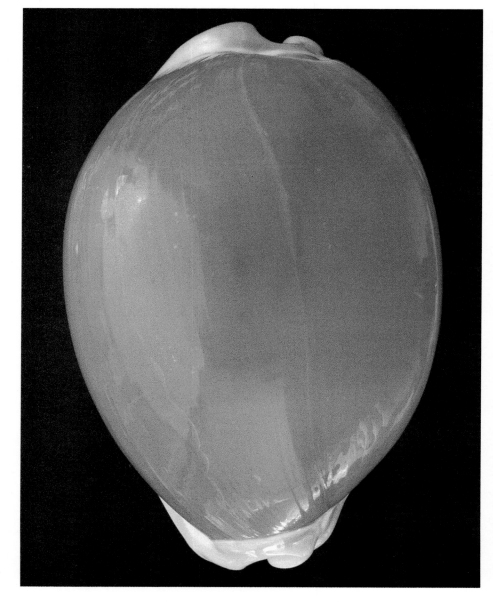

Golden Cowry
Cypraea aurantium Gmelin

For hundreds of years the cowry has been the symbol of femininity,
fertility, and child-bearing, but the beautiful, glossy Golden Cowry is
the most coveted of the cowry family. Legend has it that only the
kings, noblemen, and chieftans of Fiji were allowed to wear this shell,
because after death the shell became the home for their soul.
6–11 cm. Indo-Pacific. Rare.

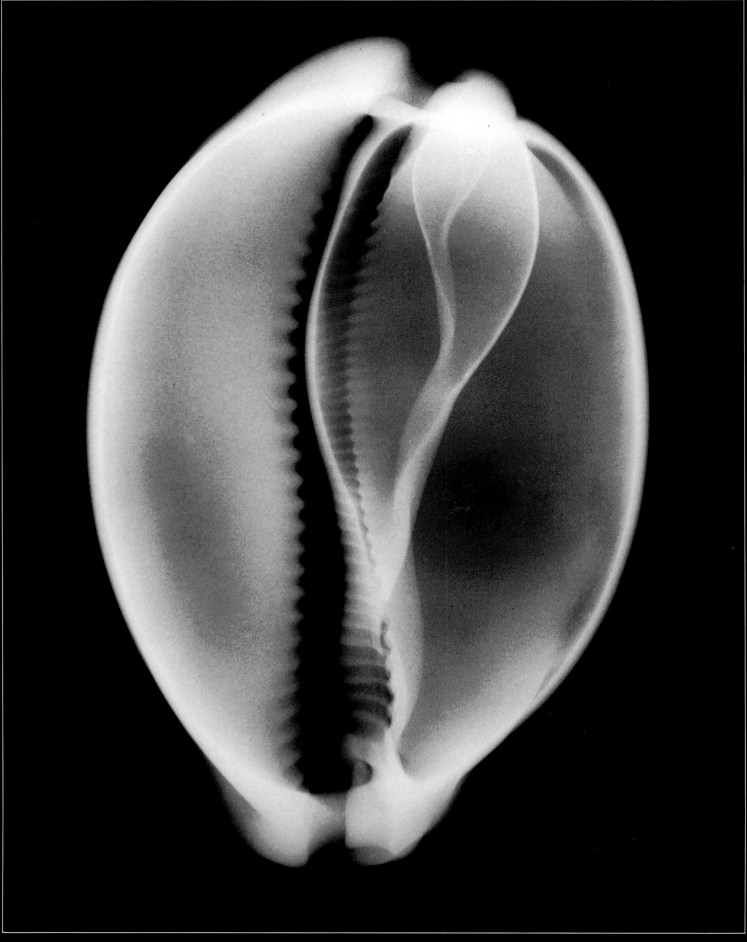

Golden Cowry

The Preparative

Then was my Soul my only All to me,
 A Living Endless Ey,
 Just bounded with the Skie
Whose Power, whose Act, whose Essence was to see,
 I was an Inward *Sphere of Light*,
Or an Interminable Orb of *Sight*,
 An Endless and a Living Day,
A *vital Sun* that round about did *ray*
 All Life, all Sence,
A Naked Simple Pure *Intelligence*.

by Thomas Traherne (d.1674)

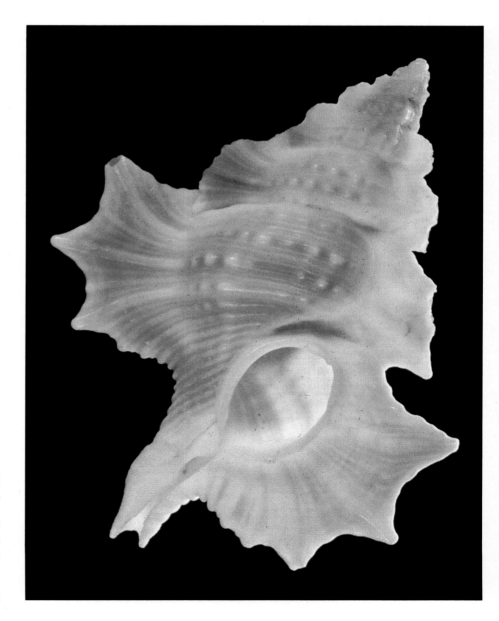

Maple Leaf Shell
Apollon perca Perry

A close relative of the Tritons, the Maple Leaf Shell is readily
distinguishable by its flattened web-like varices and its resemblance
to a maple leaf. Like other members of its family, this species'
exterior is covered in life by a hair-like periostracum.
5–8 cm. Japonic, Indo-Pacific (West Pacific). Frequent.

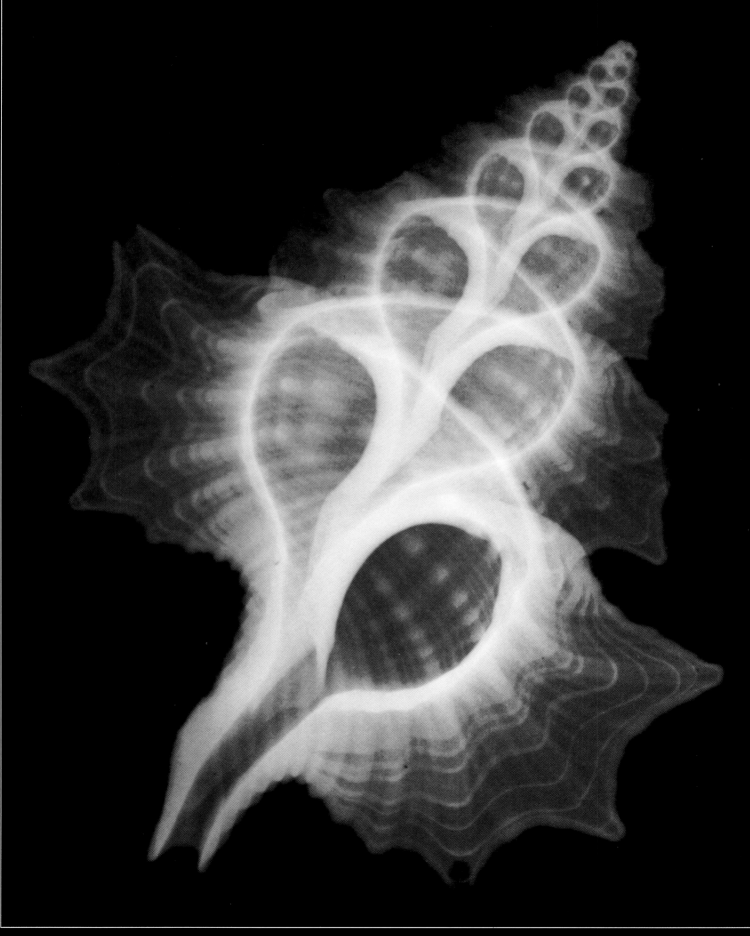

Maple Leaf Shell

Phantom

All look and likeness caught from earth
All accident of kin and birth,
Had pass'd away. There was no trace
Of aught on that illumined face,
Uprais'd beneath the rifted stone
But of one spirit all her own;—
She, she herself, and only she,
Shone through her body visibly.

by Samuel Taylor Coleridge (1772–1834)

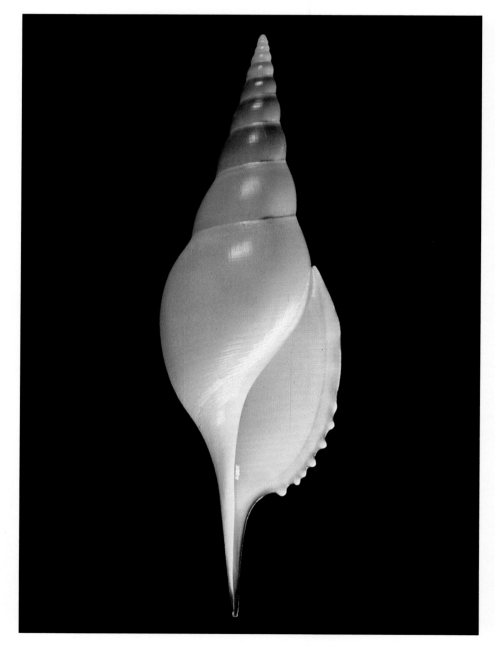

Martin's Tibia
Tibia martinii Marrat

Tibias are a small group of distinctly shaped relatives of the conchs that may easily be distinguished by the elongated siphonal canal and long slender spire. Many have three to five toothlike projections extending from the outer lip. Martin's tibia may be differentiated from other tibias by its unusually thin shell which seems to glow, particularly in the presence of artificial light.
10-12 cm. Philippines. Rare.

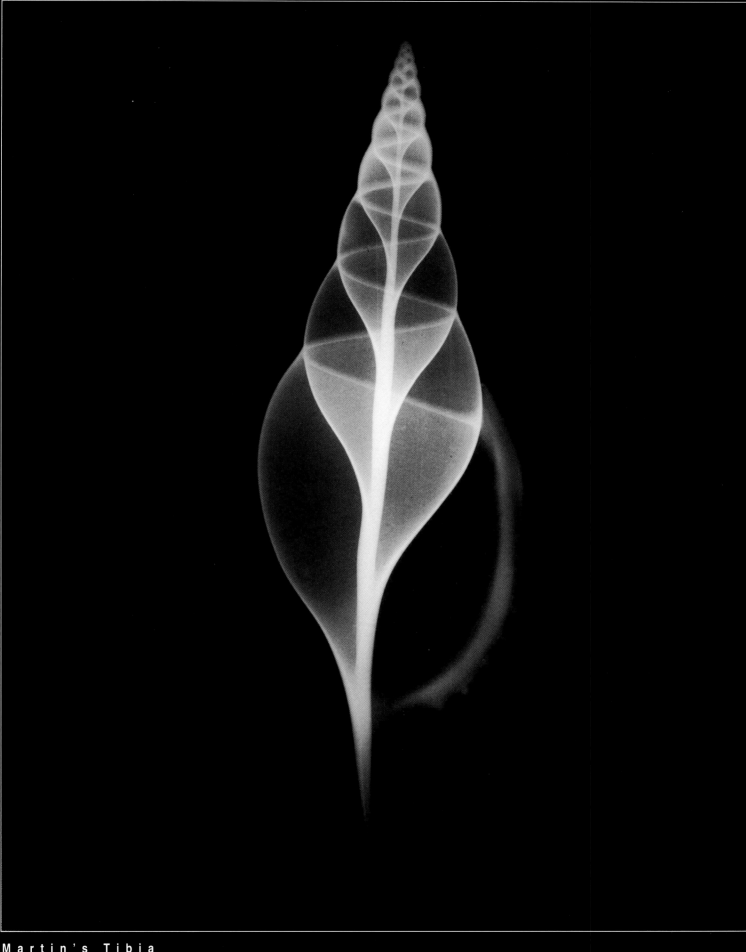

Martin's Tibia

From

I Know the Face

I know the face of him who with the sphere
 Of unseen presences communion keeps.
His eyes retain its wonders in their clear
 Unfathomable deeps.

His every feature, rugged or refined,
 Shines from the inner light; and, large or small
His earthly state, he from the world behind
 Brings wealth that beggars all.

by Robert Leighton (1822–1869)

Alabaster Murex
Murex alabaster Reeve

A very rare species obtained only by dredging, Alabaster Murex, in perfect condition, commands prices of $50 to $100. Its large size, broad, flaring, winglike varices and delicate oriental appearance all unite to make this species a prized possession of interior decorators and serious collectors. Murex of this family are restricted to the cooler waters extending from North America to Taiwan, and often are found only at great depths.
10–17 cm. South Japan-Taiwan. Rare.

Alabaster Murex

Introversion

What do you find within, O soul, my brother?
What do you find within?
I find a great quiet where no noises come
Without the world's din.
Silence is my home.

by Evelyn Underhill (1875–1941)

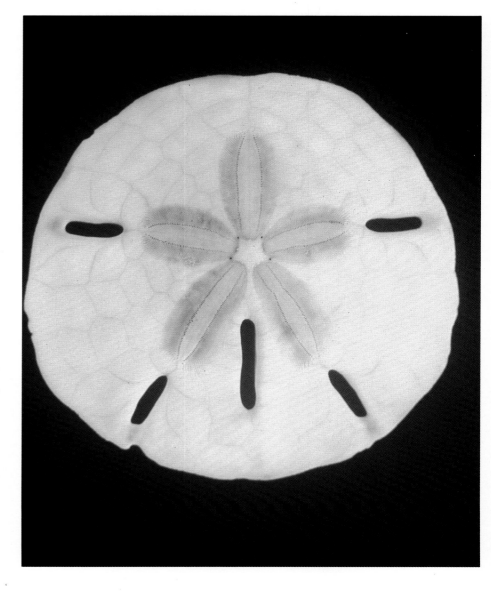

K e y h o l e S a n d D o l l a r
Mellita quinquisforma

Not really a mollusk, the Sand Dollar's closest relatives include starfish, sea urchins, and brittle stars. In life, they are dark brown or greenish, the coloration provided by countless small spines. After death, the spines drop off to reveal the white skeleton or "test" which is commonly washed ashore after a storm. The body of the Sand Dollar, like those of their relatives, which collectively are known as Echinoderms, are composed of five closely fitting and nearly identical segments. In the center is the small mouth. Keyhole Sand Dollars are named for the small slits or "keyholes" located between each segment.
10 cm. Southeast U.S.A. Common.

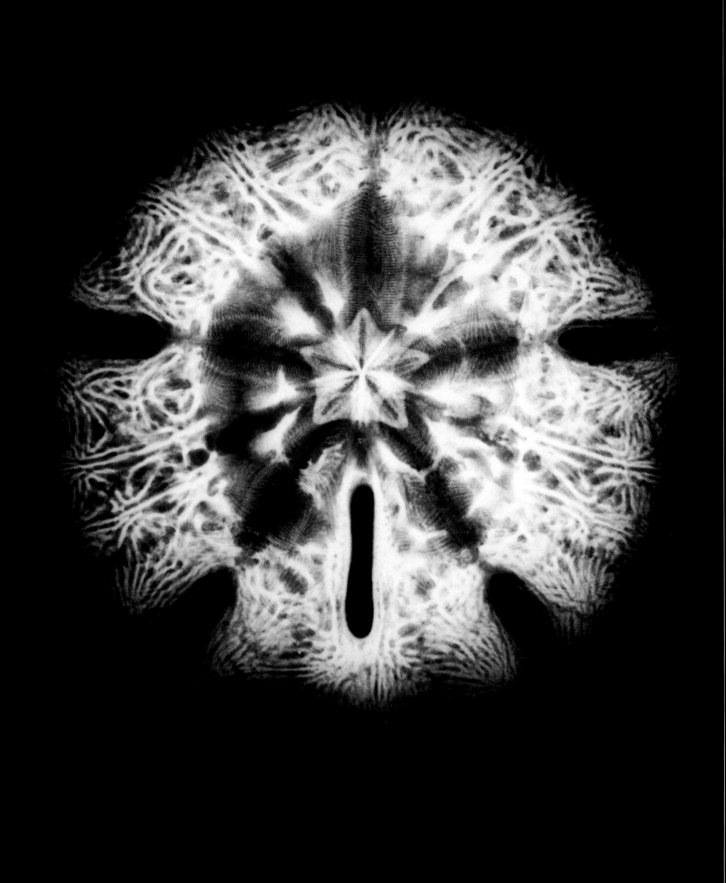

Keyhole Sand Dollar

Barnacles

My soul is sailing through the sea,
But the Past is heavy and hindereth me.
The Past hath crusted cumbrous shells
That hold the flesh of cold sea-mells
 About my soul.
The huge waves wash, the high waves roll,
Each barnacle clingeth and worketh dole
 And hindereth me from sailing!

Old Past let go, and drop i' the sea
Till fathomless waters cover thee!
For I am living but thou art dead;
Thou drawest back, I strive ahead
 The Day to find.
Thy shells unbind! Night comes behind,
I needs must hurry with the wind
 And trim me best for sailing.

by Sidney Lanier (1842–1881)

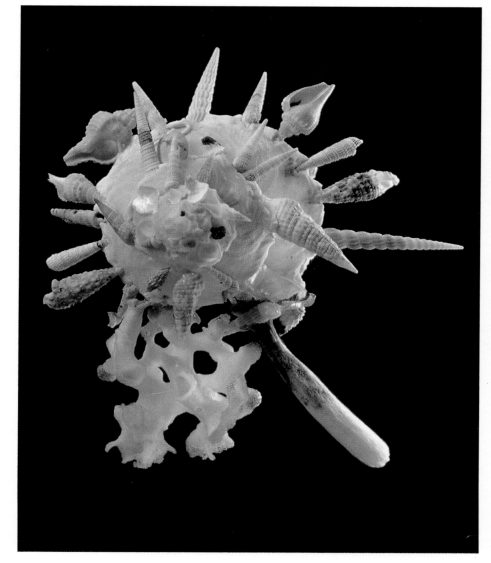

Japanese Carrier Shell
Xenophora pallidula Reeve

Carrier shells are famous for collecting empty shells, pebbles,
bits of coal, and other debris to use as camouflage and protection. Like
people, no two are alike. The abundant Japanese Carrier Shells are one of
the larger and more beautiful members of this worldwide group.
8–10 cm. Japan. Frequent.

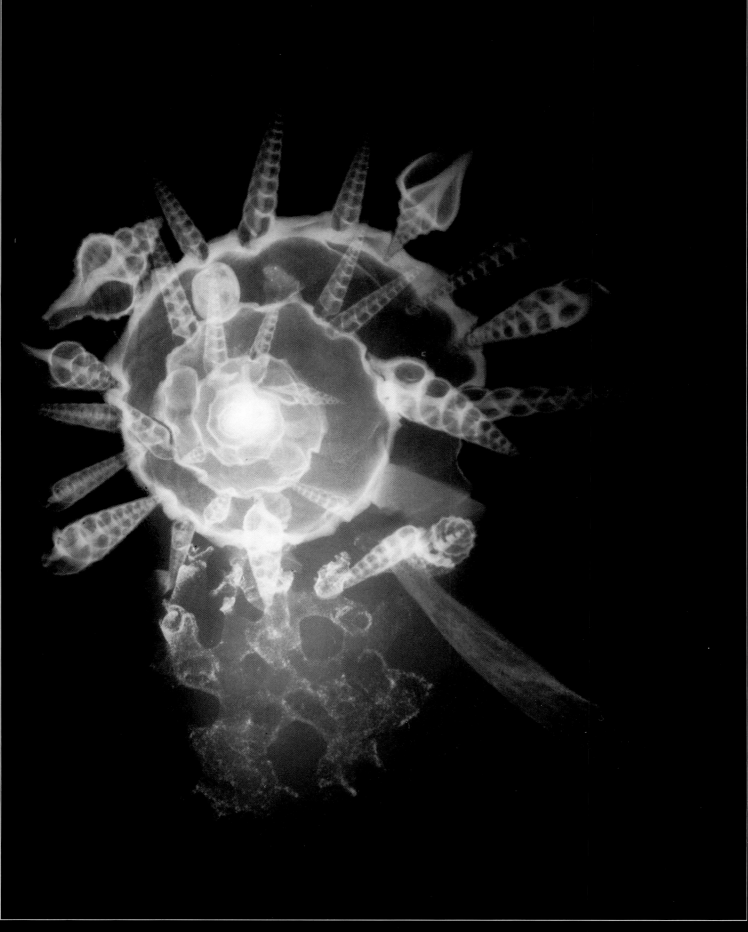

Japanese Carrier Shell

From
Phaedrus

Socrates: Beloved Pan, and all ye other gods who here abide,
grant me to be beautiful in the inner man, and all I have of
outer things to be at peace with those within.

———————❧———————
by Plato (ca. 427–347)

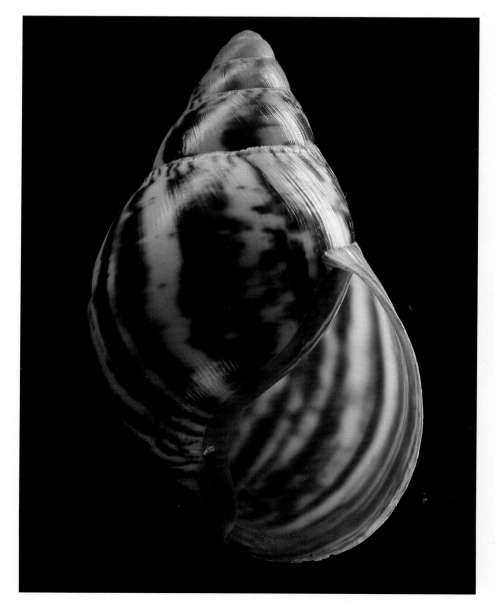

Achatina Pantherina
Ferussac

This beautiful, multi-colored land snail is rather large but
relatively thin. Its outer beauty is rivaled by its inner beauty.
It is found on islands in the Indian Ocean.
11 cm. Indian Ocean.

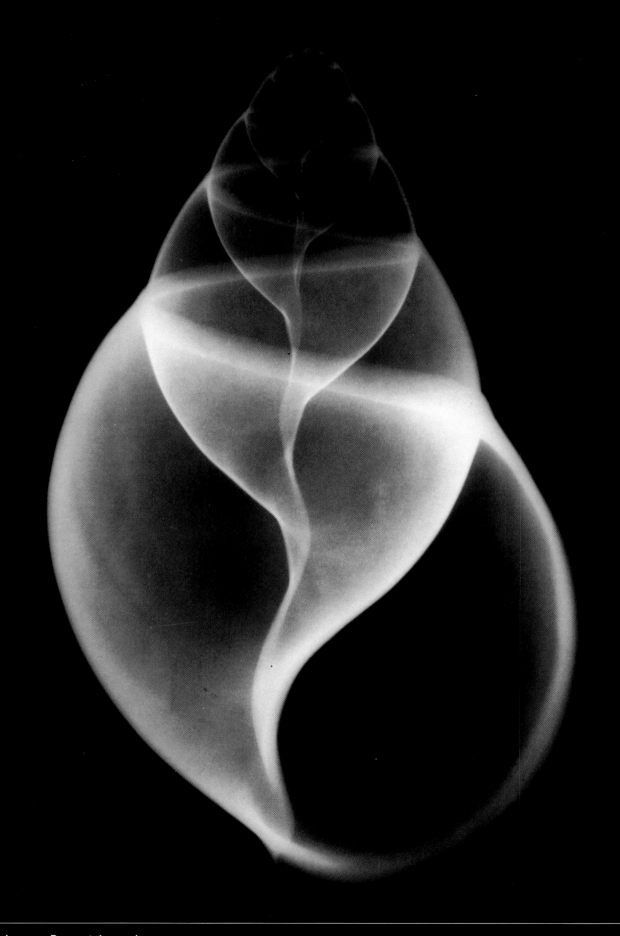

Achatina Pantherina